IMAGES
of America

COLLINGSWOOD

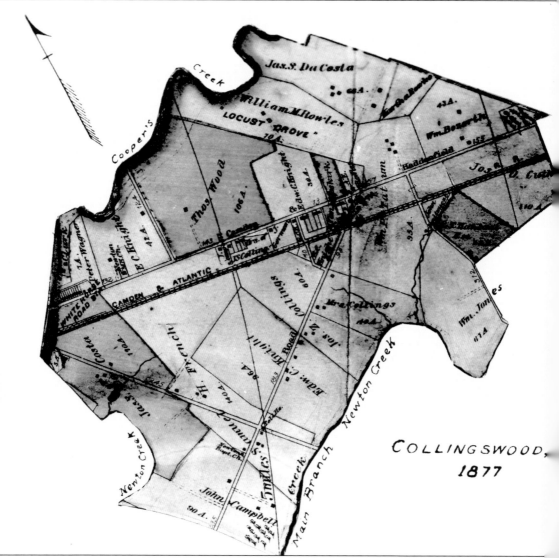

This map details land ownership in 1877 in the area that later was to be incorporated as Collingswood. At the time, Collingswood still was officially part of Haddon Township. Major landowners included familiar names in Collingswood history, such as Edward C. Knight, Joseph Z. Collings, William P. Tatem, and Joseph O. Cuthbert.

On the cover: Please see page 29. (Courtesy of Collingswood Public Library.)

IMAGES
of America

COLLINGSWOOD

Janet M. Spavlik

ARCADIA
PUBLISHING

Published by Arcadia Publishing
Charleston, South Carolina

Printed in the United States of America

Library of Congress Catalog Card Number: 2006940203

For all general information contact Arcadia Publishing at:
Telephone 843-853-2070
Fax 843-853-0044
E-mail sales@arcadiapublishing.com
For customer service and orders:
Toll-Free 1-888-313-2665

Visit us on the Internet at www.arcadiapublishing.com

To my nephew and niece, John Jr. and Joy, with love.

CONTENTS

ACKNOWLEDGMENTS

This book would not have been possible without the support and contributions of the Collingswood Public Library. The majority of the photographs featured in this book are from the library's extensive collection of historical materials. Thank you to Collingswood Public Library's director, Bradley Green, and his entire staff, who were most helpful and accommodating throughout this entire process. I also would like to thank Sandra Powell, Keith Haberern, and F. A. Collings for contributing photographs from their personal collections, and to the many other Collingswood residents who reached out to me with information and ideas for the book.

Thank you to Arcadia Publishing for entrusting me with this project, and especially to my editor, Dawn Robertson, who was incredibly patient and always available to provide support, encouragement, and her vast expertise.

Thank you to Mayor James Maley, who lent his support to this project from the onset and took time out of his hectic schedule to provide a beautiful commentary on Collingswood as a foreword to this book. Many thanks as well to Cass Young, director of communication for the Borough of Collingswood, who was wonderful in helping me to track down photographs and information.

Special thanks to Amy Gillette, my best friend and legal counsel, for your encouragement and guidance.

I took on this project to celebrate my hometown of Collingswood. However, the town would not mean all that it does to me if it were not for the four very special people who I grew up there with: my parents, John and Charlene, and my brothers, John and Thomas. I extend my most heartfelt thanks to each one of you for your infinite love and support, and for giving me so many beautiful memories. I would not have written this book if it were not for each of you.

FOREWORD

In its second century, Collingswood symbolizes the famous adage, "the more things change, the more they stay the same."

The foundation for the borough was laid in the midst of family vacations. It started as a small resort town around what is now Knight Park, and vacation bungalows were built on small lanes close to the park. You still can see those vacation homes today, originally built around the joy and happiness of family togetherness.

Through its years of growth as a suburb of the Philadelphia metropolitan area, Collingswood has developed with a heavy emphasis on schools and churches. A network of neighborhood schools began with the Zane School on Haddon Avenue—the first schoolhouse in the borough with indoor plumbing—in the heart of the downtown business community. That network expanded to five neighborhood schools as more and more housing was built and developed. Churches of all denominations were built, seemingly on every corner. Even as Collingswood developed into a suburb, there always was a thread of family.

Into modern times, Collingswood's housing stock developed a mix of sizes, from townhouses to large mansions. As we have entered into the new millennium and modern-day forces complicate the lives of the residents of Collingswood and the world beyond, we grapple with the explosion of technology and our ever-changing global community; however, the reason people continue to call Collingswood home is the central role of family in all aspects of the community. Collingswood has developed a thriving recreation program that involves all children in physical activities and the arts. Collingswood's business community has undergone a renaissance spurred by the arts, an influx of an ever-changing variety and mix of people, and a quality of life that fosters family growth. The Zane School—that first schoolhouse with indoor plumbing—has been restored as the home of architects and other professionals. Collingswood has undergone a series of reinvention phases over its history, but its soul has been in a character that is grounded in family and a community of people.

Its founders created a sturdy plan and design for the bricks and sticks of housing and other constructed improvements: That constructed community has matured into a close neighborhood of caring, involved families. While the times, the problems, and the people have changed, there continues to be an allure for families of all shapes and sizes. People live here because they enjoy the high quality of life with their immediate family and with their community family; the tradition of strong family life is the reason why Collingswood continues to be "where you want to be."

M. James Maley Jr.
January 2007

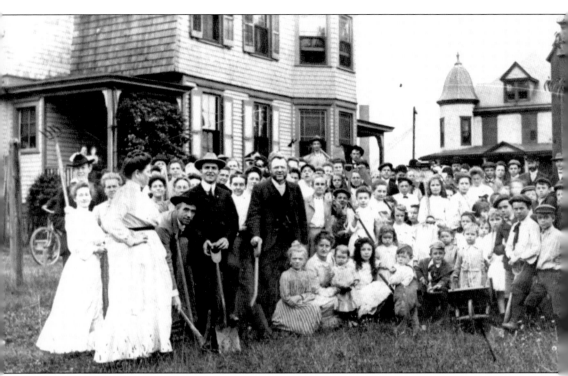

Parishioners of the First United Methodist Church gathered on June 8, 1903, at 6:00 a.m. for the groundbreaking of a new stone church at Park and Dayton Avenues. Just after 7:00 a.m., seven workmen began excavating.

INTRODUCTION

While Collingswood officially was incorporated in 1888, the history of its land and people can be traced back more than a century before when a ship called *Ye Owner's Adventure* arrived from Dublin, Ireland, at what is now Salem, New Jersey, on November 16, 1681. The ship carried several passengers who would become instrumental in the settling of the land now known as Collingswood. They included Thomas Thackara, Mark Newbie, a young Thomas Sharp, William Bates, and George Goldsmith. When they landed, they met another famous figure in Collingswood history, Robert Zane (who earlier had arrived in the New World) along with his wife, Alice, a Native American.

The following spring of 1682, several of these adventurous colonists left Salem to explore and settle new land. They set sail northward, up the Delaware River and into the mouth of Newton Creek. They chose the name Newton Colony for their new settlement, although the origin of the name has been open to speculation. Some historians say the naming was in honor of Sir Isaac Newton, while others believe it was derived from "New Towne." Regardless of the name's origin, Newton Colony, which extended from Gloucester to Cooper River (then known as Cooper's Creek) and included parts of Haddon Township, was the first English-speaking colony in the area.

The Newton colonists agreed to divide up their new land, and each built their homes along the waterway, with their respective parcels of land extending back from Newton Creek. Most of these early settlers were devout Quakers, and in 1684, they built the Friends Meeting House, one of the area's first non-residential structures, on Newton Road (now Collings Avenue). It stood until 1817, when it was destroyed by fire.

Another one of these early Quaker settlers was Francis Collins, who owned about 500 acres of land by Kings Highway. Many years after Collins first settled in Newton Colony, his great-nephew married Esther Zane, the great-granddaughter of Robert Zane, at Christ Church in Philadelphia. The groom's name was listed with a slightly altered spelling, as Richard Collings. Richard and Esther Collings, descendants of those original Newton Colony settlers, became the ancestors of the Collings family, for whom the town of Collingswood is named. Their granddaughter Rebecca Collings married Jonathan Knight, and in 1813, the couple had a son, Edward Collings Knight.

On February 23, 1865, an act of the New Jersey Legislature split Newton Township and designated more than 5,000 acres of its eastern sector as Haddon Township. This new township included Collingswood as well as several other neighboring towns. While Collingswood would not officially split from Haddon Township for more than 15 years, it already was taking on its own identity. In 1873, the neighborhood made a monumental decision when it voted to ban the sale of alcohol on its land, a decision that still stands today.

When a petition to Washington, D.C., was granted in 1881 to establish the neighborhood's own post office, a name of the neighborhood was required. To settle the matter, 10 prominent citizens gathered in a shoe shop owned by James Riggins: Armour Shannon, Richard Shannon, Richard T. Collings, Joseph Stokes Collings, Chaukley Parker, William R. Eldridge, Joseph E. Tatem, J. Fletcher Foster, Ellis Price, and Riggins himself. While other names were considered, they finally decided on Collingswood, in honor of the family that was the area's major landowners, as well as descendants from Newton Colony's original settlers.

In early March 1888, a late winter blizzard, now famously known as the blizzard of 1888, descended on the small community of Collingswood with driving snow and high winds, holding residents captive in their homes for three long days. When the snow finally melted and spring arrived, thoughts turned to independence. An election was held, and the neighborhood voted to secede from Haddon Township and incorporate as the Borough of Collingswood. Men left their farms and traveled down dirt roads and along wooden sidewalks to cast their ballots. By nightfall, kerosene street lamps lit the way for a few late voters. As of May 22, 1888, all votes were cast, and Collingswood officially was proclaimed a borough.

In its formative years, Collingswood enjoyed incredible growth. New residents were drawn by its proximity to Camden and Philadelphia, which both were easily accessible via the town's two railroad stations, as well as by its excellent public and private schools and its network of churches. By 1905, seven churches already existed in the small, deeply religious community. At the beginning of the 20th century, town fathers advertised in newspapers that Collingswood was "the fastest growing community east of the Mississippi River." Whether or not the claim was entirely factual, Collingswood's incredible growth at that time was undeniable—from 1900 to 1920, the population grew from 1,663 to 9,000.

Another important factor in Collingswood's impressive early growth and one of the most monumental events in the town's history was Edward C. Knight's generous gift of Knight Park to the residents of Collingswood. In the late 1800s, Knight and his cousin Richard T. Collings were the principal land developers in the area. They planned for a tract of land of approximately 100 acres in the geographic center of Collingswood to be donated to the area's residents as a park in memory of Knight's beloved mother, Rebecca. Knight dedicated the park in 1888 and oversaw its operation through his Collingswood Land Company until his death on July 21, 1892. After Knight's death and in accordance with his will, Knight Park legally was established as a gift to Collingswood and as a memorial to his mother and was dedicated as such in May 1893. The park, which drew visitors from as far as Camden and Philadelphia, quickly became the center of activity in Collingswood and a major draw for potential home buyers.

The collection of photographs in this book will take you on a journey of Collingswood's rich history from before its incorporation in 1888 through 1950. Unless otherwise noted, all materials presented in this volume are courtesy of the Collingswood Public Library.

One

A MORAL FRAMEWORK

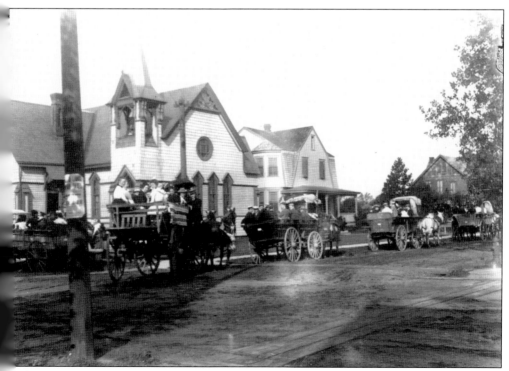

front of the First United Methodist Church at the corner of Park and Dayton Avenues,
arishioners set off in horse-drawn wagons for a church picnic in the summer of 1901.

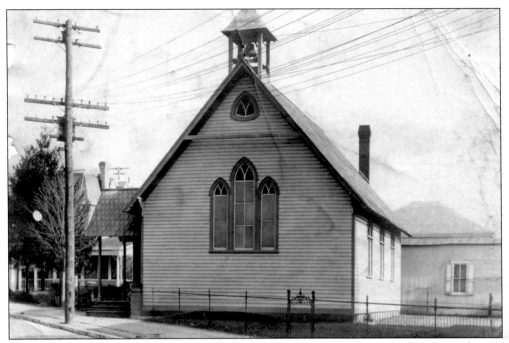

The cornerstone of the chapel of the Holy Trinity Episcopal Church was laid on December 12, 1886, at the corner of Haddon and Collings Avenues. The famous poet and Camden resident, Walt Whitman, gave a reading of his poems here in exchange for silver, which he generously donated back to the church. This building was used until 1917, when a new church was built at Haddon and Fern Avenues, where the congregation still resides.

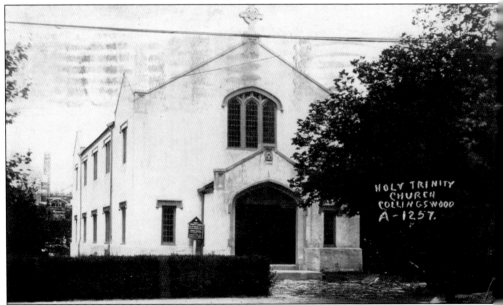

HOLY TRINITY
CHURCH
COLLINGSWOOD
A-1257.

Construction was completed on the Holy Trinity Episcopal Church's new structure at Haddo and Fern Avenues in 1917, at the time this photograph was taken. Behind the church, to th left, the Collingswood Presbyterian Church is shown under construction at Maple and Fer Avenues; it was completed later that same year.

Organized in 1889, the First Baptist Church of Collingswood was one of the town's first congregations. Church members initially met in this building on the corner of Haddon and Washington Avenues, shown here in 1890. After the congregation relocated to a new church, this building became known as Stanley Hall and hosted movies and entertainers.

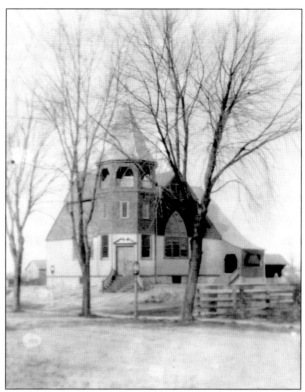

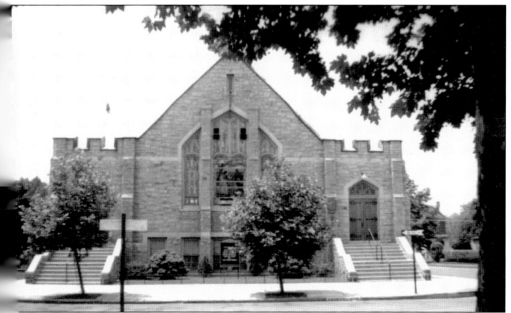

s the town's population and church membership increased, the First Baptist Church grew out f its home on Haddon and Washington Avenues and purchased ground for a new structure, 10wn here in 1938, on the corner of Maple and Frazier Avenues. In 1949, construction began on 1 education building behind the church, which continues to house a nursery school. (Courtesy Sandra Powell.)

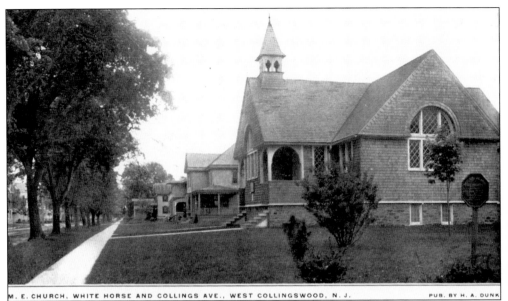

On March 5, 1902, the West Collingswood Methodist Episcopal Church was organized and initially held services in the firehouse of the West Collingswood Fire Company. In 1903, the Collingswood Land Company presented this site at Collings Avenue and the White Horse Pike to the Methodist Church. The cornerstone of the new building was laid on June 20, 1903, with the church's pastor, Rev. Daniel Y. Stephens, officiating.

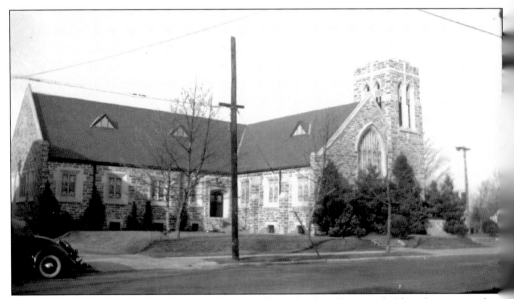

As the congregation of the West Collingswood Methodist Episcopal Church grew and it facilities became inadequate, parishioner Emma Frances Childs planned for a new churc to be erected. After she passed away in 1922, her husband, S. Canning Childs, a prominen businessman and philanthropist, fulfilled his wife's dream by donating $100,000 to erect th present structure, photographed here in 1939. The structure was dedicated on January 5, 192 and the congregation renamed Frances Childs Methodist Episcopal Church in her memor (Courtesy of Sandra Powell.)

14

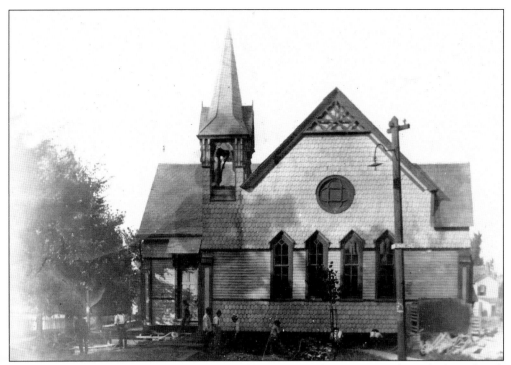

In February 1887, 13 charter members assembled to form the First United Methodist Church and to arrange for a building to house the congregation. This frame structure was erected at the corner of Park and Dayton Avenues and dedicated on December 4, 1887. These photographs show the exterior and interior of the structure when it was first built. At the time, the church had approximately 30 members.

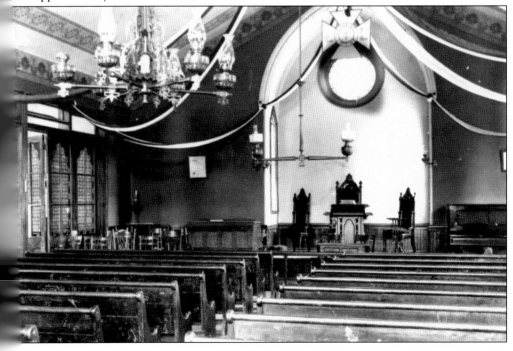

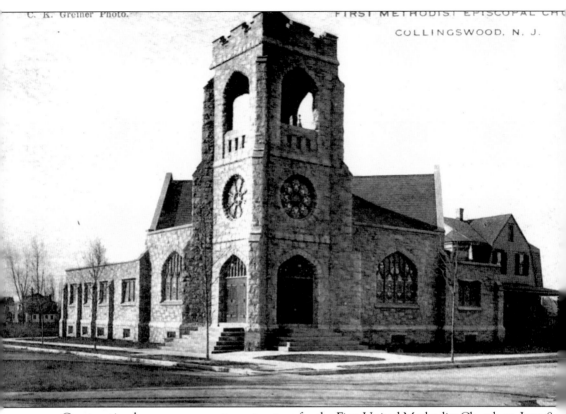

Construction began on a new stone structure for the First United Methodist Church on June 8, 1903. It was completed a year later and dedicated on June 29, 1904. The original frame structure was turned to face Dayton Avenue and renovated into a Sunday school.

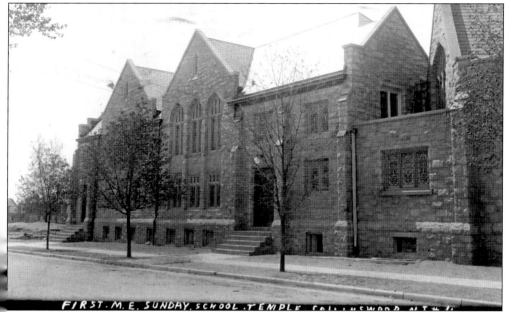

FIRST. M. E. SUNDAY. SCHOOL .TEMPLE. COLLINSWOOD N.J.#II

In 1909, First United Methodist Church pastor Rev. J. F. Shaw undertook the building of a great Sunday School Temple for the congregation. The building was constructed of granite to match the church structure and had a seating capacity of 1,100. These photographs show the exterior and interior of the completed structure.

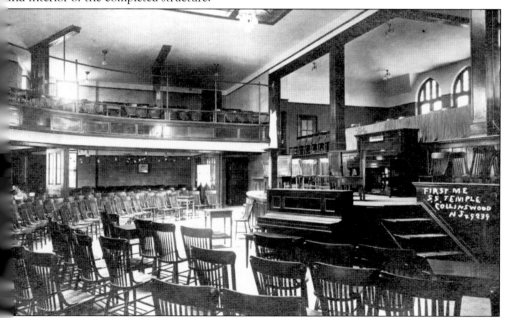

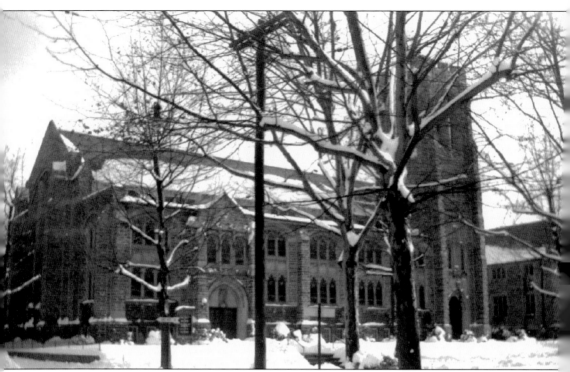

The Collingswood Presbyterian Church officially was formed on March 11, 1903, with 34 charter members. The first sanctuary was built at Haddon and Frazier Avenues; the building later was sold to the borough and served as part of the Collingswood Public Library until 1974. On October 16, 1916, ground was broken for the new church building on the current site at Ferr and Maple Avenues. In 1929, a major remodeling was accomplished in conjunction with the addition of an education building. This photograph was taken of the church in 1938. (Courtesy of Sandra Powell.)

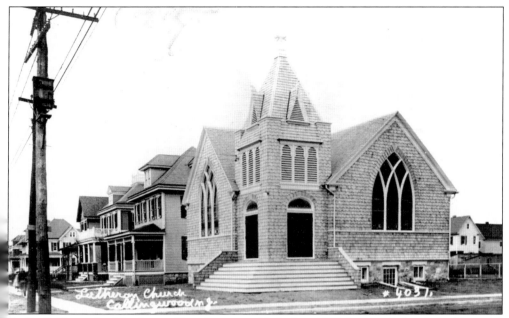

St. Paul's Evangelical Lutheran Church was established in 1905. Its initial church building was located on the corner of Woodlawn and Haddon Avenues.

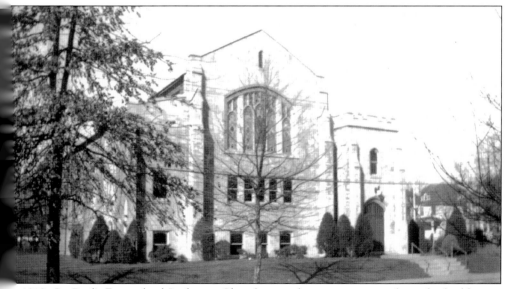

1912, St. Paul's Evangelical Lutheran Church moved its congregation from the building at oodlawn and Haddon Avenues to a new building on Park and Dill Avenues. (Courtesy of ndra Powell.)

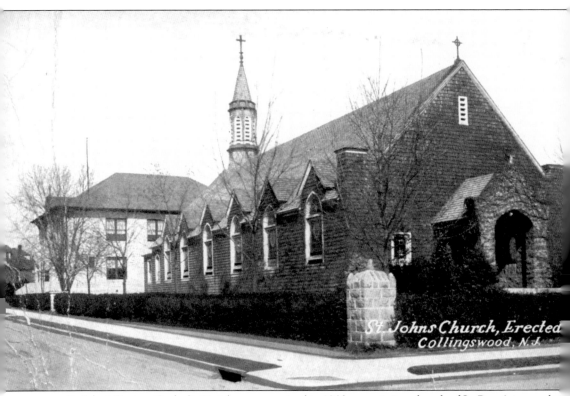

St. John's Roman Catholic Parish was organized in 1903 as a mission church of St. Peter's in nearby Merchantville. In 1904, this church building was constructed on a cornfield donated by Matilda Spuhler at the corner of Park and Lees Avenues at a cost of about $5,000. The cornerstone was laid on August 14, 1904, and the church named St. John's in memory of Spuhler's father, John Schnitzius. In 1954, the present church structure was completed on the same site for $220,000.

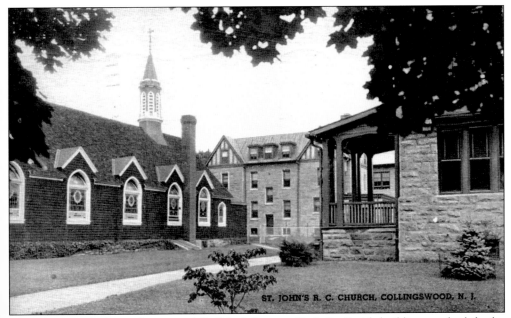

This photograph shows the original St. John's Roman Catholic Parish building on the left, the convent in the center, and the rectory on the right. In 1925, Anna O'Neill built the three-story stone convent in memory of her husband, Capt. John O'Neill. The rectory structure was built with funds collected from parishioners in 1926.

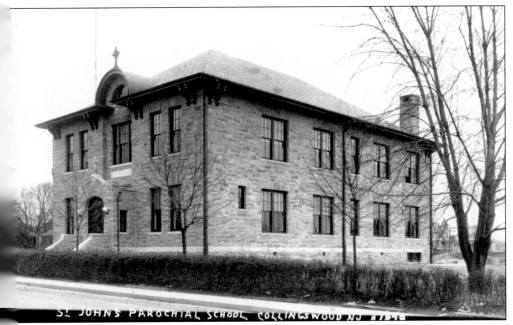

1 1920, St. John's parochial school was built for $50,000. It was a two-story stone structure ontaining eight classrooms. The school opened in February 1921 to 100 pupils. The Sisters of 1ercy of North Plainfield, New Jersey, staffed the school. This building later was replaced by the urrent structure in 1969.

In the early 1900s, the First United Methodist Church aided in the establishment of a church in the Stonetown section of Collingswood, a neighborhood of about a dozen twin homes at the intersection of Haddon Avenue and Route 130, then known as Crescent Boulevard. A structure was built in September 1908, and the congregation became known as the Haddon Avenue Chapel. As the congregation grew and established itself apart from the First United Methodist Church, ground was broken on a new sanctuary in 1922 at Wayne Terrace and Haddon Avenue. The name Embury Methodist Episcopal Church was chosen in memory of Philip Embury, the first Methodist preacher to settle in the American colonies. The completed structure is shown here in 1938. (Courtesy of Sandra Powell.)

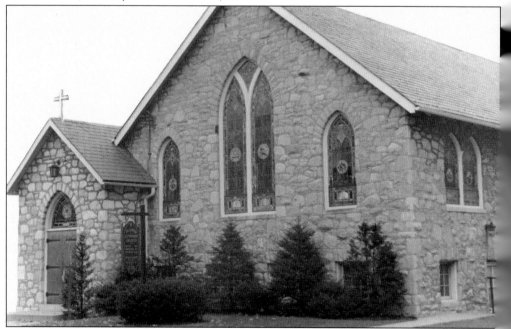

St. Luke's Evangelical Lutheran Church of West Collingswood was founded in 1916 with 38 charter members. The congregation initially met in Heck-Ames Hall at Richey and Colling Avenues. Construction on a new church began in November 1916 and was completed th following year. Several renovations were made to the building throughout the years, until it wa completely destroyed by a fire on March 14, 1975.

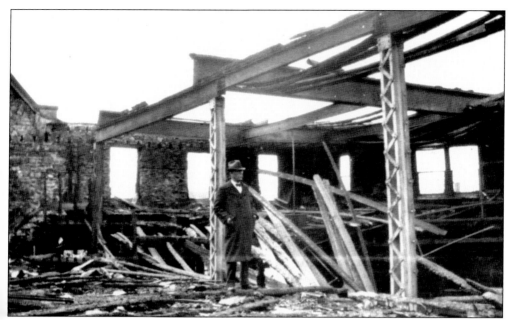

A few minutes after midnight on April 11, 1932, fire engulfed the First United Methodist Church Sunday School Temple and damaged the sanctuary beyond repair. In this photograph, Ira Shaw, long-time station agent of the Camden and Atlantic Railroad, stands among the ruins later that same day. After the debris was cleared, a farewell service was held in the old church on August 21, 1932; the congregation stood or sat on boxes and other makeshift pews during the service.

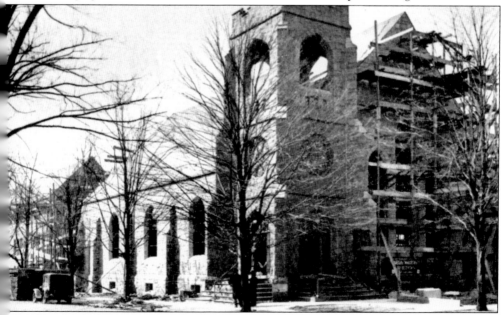

his photograph shows the reconstruction of the First United Methodist Church in February)33. The cornerstone was laid on November 6, 1932, but construction was halted when the uilding funds became tied up in the failure of the Collingswood National Bank in March 1933. he church filed suit against the bank and eventually recovered most of its money to proceed ith the building.

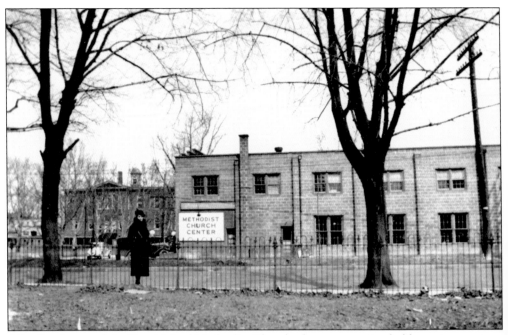

After fire destroyed the First United Methodist Church, the congregation held evening services, youth meetings, and prayer meetings in a church center established on the second floor of Van Meter's Garage, shown here, at Irvin and Atlantic Avenues. The second floor was furnished with equipment that was salvaged from the fire. Morning services and Sunday school were held in the junior high school auditorium.

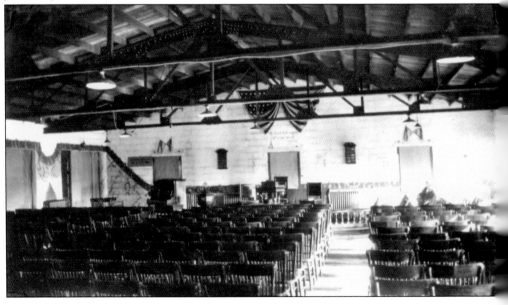

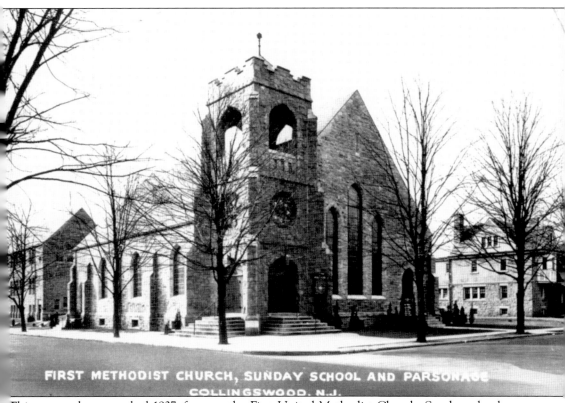

FIRST METHODIST CHURCH, SUNDAY SCHOOL AND PARSONAGE
COLLINGSWOOD, N.J.

This postcard, postmarked 1937, features the First United Methodist Church, Sunday school, and parsonage after it was rebuilt in 1934. The new sanctuary was dedicated on February 18, 1934, with a sermon led by Rev. H. C. Leonard, followed by a week of services calling attention to the mercies of the Lord.

In March 1938, a congregation of 1,200 parishioners withdrew from the Collingswood Presbyterian Church over doctrinal differences with the General Assembly of the Presbyterian Church, United States. Led by their pastor, Rev. Carl McIntire, the congregation initially met in a tent erected at the corner of Haddon Avenue and Cuthbert Boulevard until this wooden tabernacle was completed on that site on May 29, 1938. (Courtesy of author's collection.)

Two

BUILDING A COMMUNITY

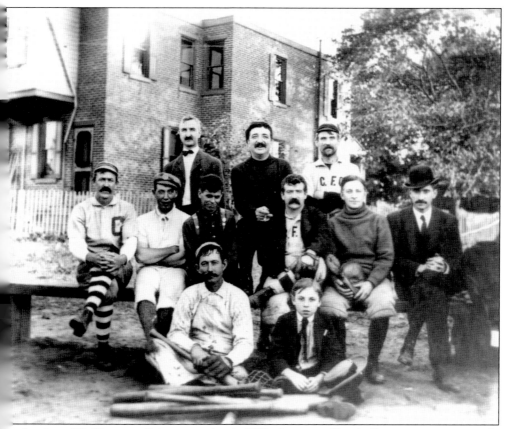

t the time of Collingswood's incorporation in 1888, the game of baseball was gaining nationwide
pularity. By the early 20th century, Collingswood had organized its first baseball team, shown
re in 1901. The team played its home games on a field that extended between Lincoln and
ashington Avenues, just off Haddon Avenue.

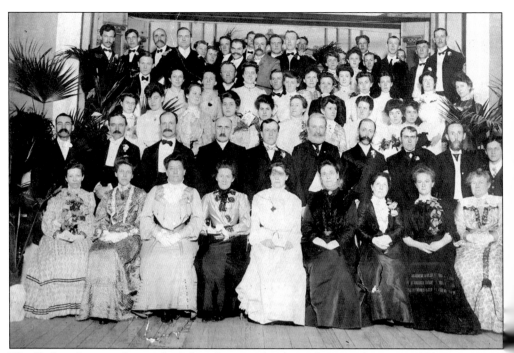

The Kipling Literary Society had this photograph taken of its members at its fifth anniversary celebration held at Tatem Hall on May 2, 1904. The Kipling Literary Society, organized by C. W. Batchelor and Edward S. Sheldon, became active in the organization of the Collingswood Library in 1910.

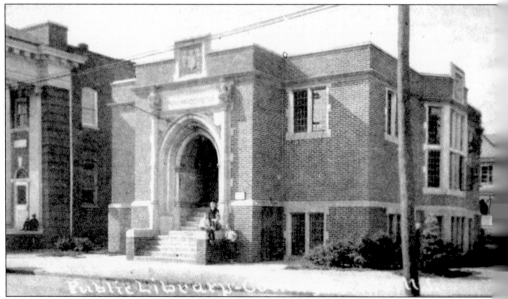

Originally established in 1911 at 725 Haddon Avenue, the Collingswood Public Library constructed a new building in December 1917 at the corner of Haddon and Frazer Avenues with a $15,000 grant from the Andrew Carnegie Foundation. It was joined to the old Collingswood Presbyterian Church building, which was utilized as the library's children's section. The present structure was erected in the early 1970s at the same location.

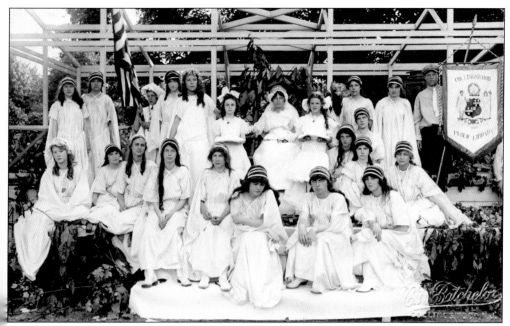

The Collingswood Public Library, established in 1911, sponsored a variety of activities in its inaugural years to raise funds, including cake sales, lectures, and the Children's Carnival, an event featuring pageants and baby contests. These photographs were taken at the Children's Carnival, held in Knight Park, on July 4, 1913.

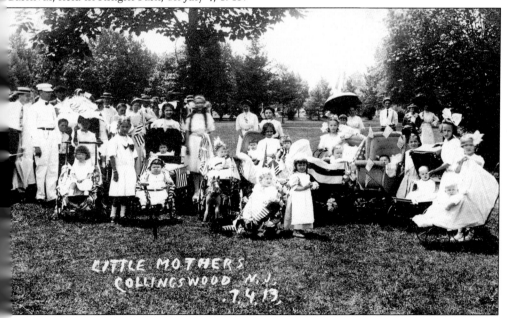

A Local Institution

THE WEEKLY RETROSPECT

There is not another paper beside the *Retrospect* under the sun that cares a rap about Collingswood and its interests. Collingswood and the territory we cover might be wiped off the map and not another paper in the world would be bothered. The principal interests of the closest of them lies in a city the concerns of which are frequently opposed to those of our town, and papers published there frequently advocate actions and causes that are not to the interest of Collingswood.

It costs a very considerable sum every week to publish *The Retrospect,* and it needs your support. Even if you don't agree with everything it says and though it may sometimes make a mistake,—it always, all the time, stands for the welfare of the Borough, and works for the best interests of its people.

Unless it has the support of local people it cannot exist, so do your part —boost it—subscribe for it, patronize its advertisers—and we'll promise to do better and better as time goes by, and make it a credit to the town.

Our conception of an ideal town paper is one that is absolutely independent as regards politics, is inflexible in its stand for moral rectitude, is perfectly just to every citizen, is persistent in effort to benefit the community and advance its interests, and that prints all the news that's fit to print, but none of scandal, vilification or of sensational exaggeration, and we endeavor to live up to this ideal. We feel that as the mouthpiece of the town, its columns should be open to every citizen who desires to discuss matters of public interest, and we are, and always have been, ready to publish any such communication even though it does not coincide with our views, providing that it is free from vilification or defamatory matter and is not malicious or demoralizing. We stand for the "square deal" and are not "controlled." THE EDITOR.

George M. DeGinther, editor-publisher of the *Retrospect* from 1905 to 1939, published this impassioned message to Collingswood residents in the program book celebrating the town's 20th anniversary. Launched in July 1902, the *Retrospect* continues to serve as "Collingswood's Hometown Newspaper" more than 100 years later.

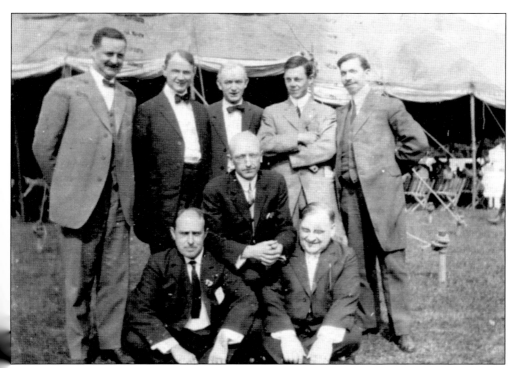

Chautauqua, a traveling show of cultural entertainment, was an annual summer event in Collingswood, held at Knight Park. On June 23, 1913, a group of doctors posed before a tent at that year's Chautauqua. They are, from left to right, (first row) Dr. Edward S. Sheldon (the town's first physician), and Dr. William Chamberlain (pioneer druggist and Presbyterian church leader); (second row) Dr. Grafton E. Day (once a candidate for the United States Senate); (third row) Dr. Hayes, Dr. T. W. Madden, Dr. E. B. Rogers (first commander of the American Legion Post-Collingswood), Lester Kirby (a member of Chautauqua committee), and Dr. E. Coffee.

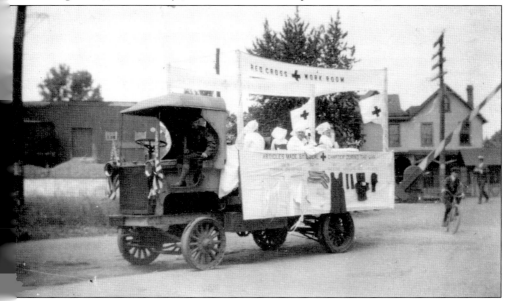

mobile Red Cross workroom travels down Collings Avenue in 1910.

In the early 1900s, the Camden County Country Club was located along Browning Road near Cooper River. It boasted a nine-hole, 2,256-yard course and a membership of almost 200 men and women. However, the belief that it promoted playing golf on Sundays and rumors of members drinking alcoholic beverages on the premises did not sit well with Collingswood's moral majority, and it soon closed its doors. Members relocated their club out of Collingswood to a place called Tavistock.

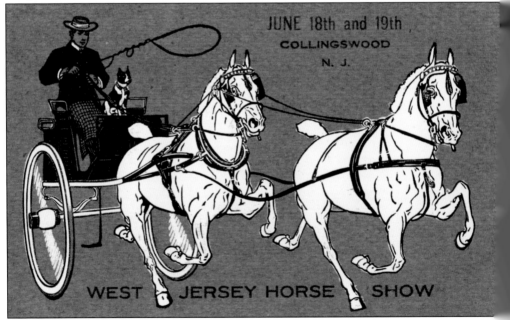

The West Jersey Horse Show was a famous event held in Collingswood around the early 20th century, with the finest horses coming from all over the east coast to compete. The event was held at the racetrack at the Camden County Country Club.

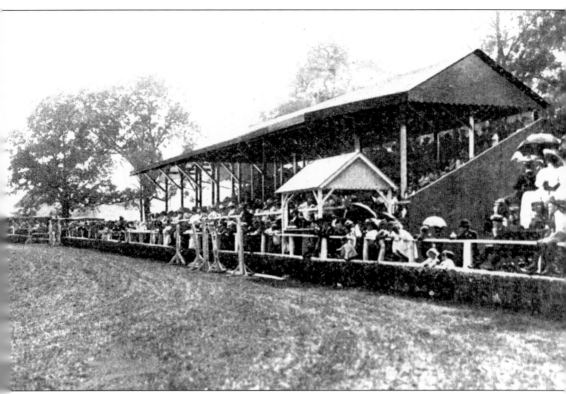

A racetrack at the Camden County Country Club was located in the area where Roberts Pool stands today. This photograph of the track was taken during the West Jersey Horse Show in 1911.

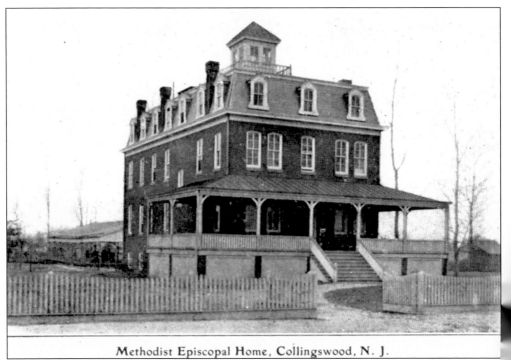

Methodist Episcopal Home, Collingswood, N. J.

Incorporated on February 3, 1890, the Home for the Aged and Infirm of the Methodist Episcopal Church of the County of Camden has been known by several other names throughout its long history, including the Methodist Home, the Old Folks' Home, and Collingswood Manor. The building was constructed in 1891 on land donated by Edward C. Knight at the corner of Haddon and Zane Avenues. It originally served the needs of only female senior citizens. These photographs show the exterior of the original structure and the interior of the original office.

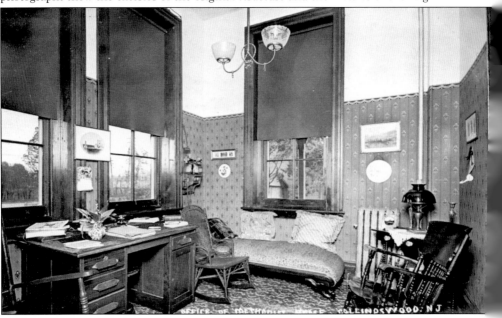

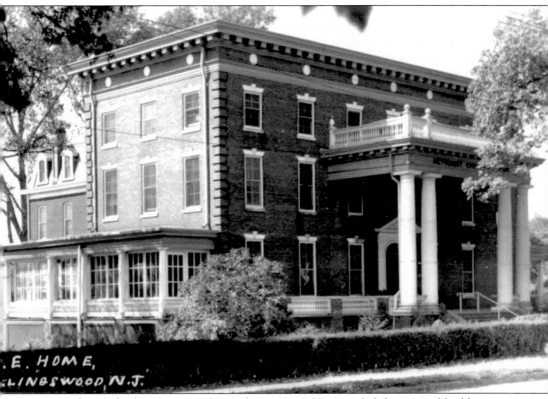

E. HOME,
LINGSWOOD, N.J.

enovations to the Methodist Home in 1910 and again in 1938 expanded the original building
ructure, as the need to accommodate more residents increased. In 1938, the home began to
cept men as residents. The pavilion shown to the rear of the building was used for picnics and
her events.

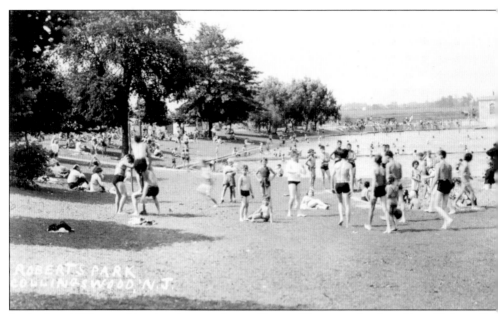

In the late 1930s, an old swimming pond near Cooper River was developed into Roberts Park Swimming Pool, for use by Collingswood residents. The park featured a swimming pool, picnic area, and playground.

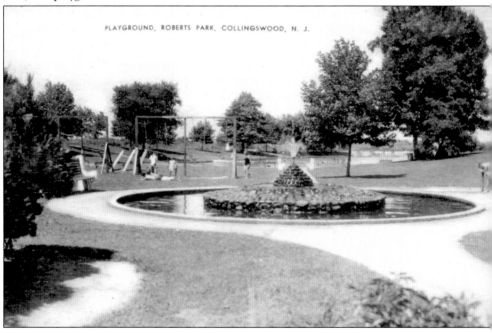

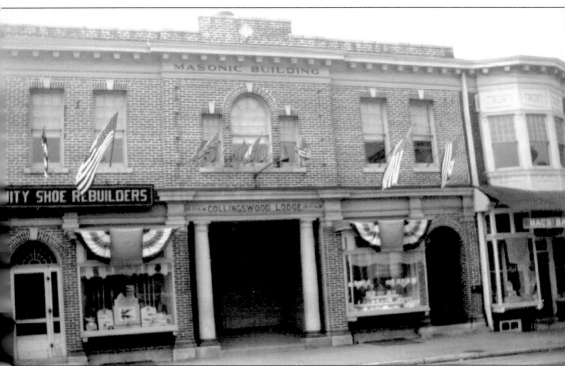

Collingswood Lodge No. 210, Free and Accepted Masons, was founded on June 9, 1917, and originally met on the second floor of the Collingswood National Bank. In 1921, the Palms Theatre, a motion picture house, was purchased and remodeled into the Masonic Temple on Haddon Avenue near Irvin Avenue. The group had 103 charter members; Henry W. Mohrfeld served as the first worshipful master. (Courtesy of Sandra Powell.)

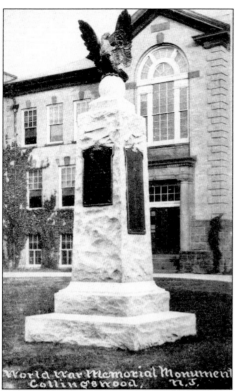

This monument honoring Collingswood residents who served in World War I originally stood in front of the old high school building on Collings Avenue. It now resides on the edge of Knight Park at the corner of Collings and Park Avenues.

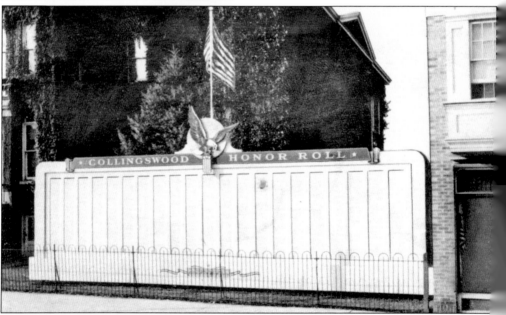

During World War II, an honor roll board bearing the names of Collingswood residents i service was placed at the Borough Hall. That board soon became too small, and a larger on pictured here, was built at Irvin and Haddon Avenues in front of the Zane School. Approximate 1,500 names were listed on this board, of whom about 50 had died in the war. Howard Scarboroug maintained the board throughout the duration of the war.

Three

THE PARKS

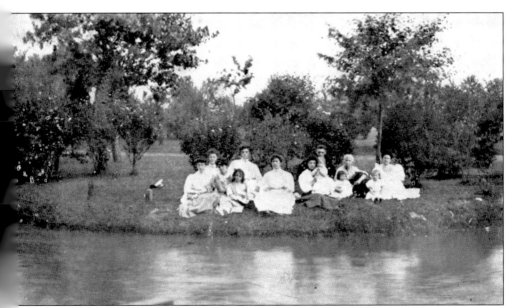

visitors to Knight Park gather on the banks of a lake on this postcard dated 1906. A large
quantity of postcards was produced throughout the first two decades of the 20th century that
capture the beauty of the park in its early years, from seemingly every angle.

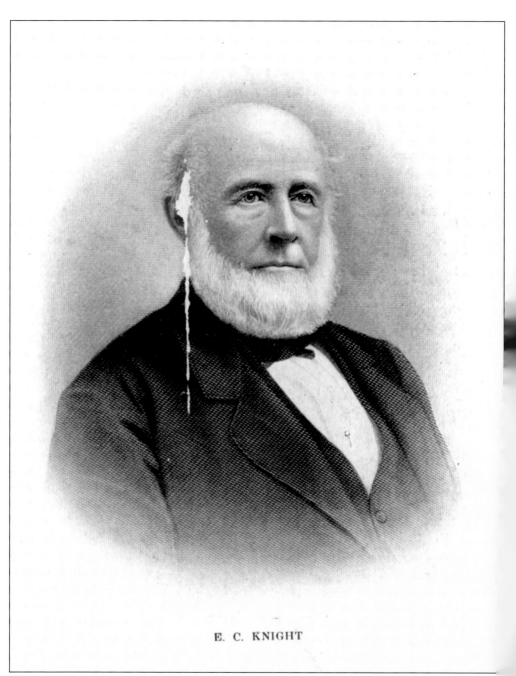

E. C. KNIGHT

Edward C. Knight was a successful Philadelphia businessman and by the 1880s, the large[r] landowner in Collingswood, operating through his corporation, the Collingswood Lan[d] Company. Knight, who was a cousin of Richard T. Collings, was born in Newton Township i[n] 1813 and grew up in the house now known as the Collings-Knight House at Collings Aven[ue] and Browning Road. In 1888, Knight dedicated about 100 acres of his land to the town for u[se] as a park. After Knight's death on July 21, 1892, Knight Park was legally gifted to Collingswoo[d] and established as a memorial to Knight's mother, in accordance with his will. The park w[as] formally dedicated a second time in the spring of 1893.

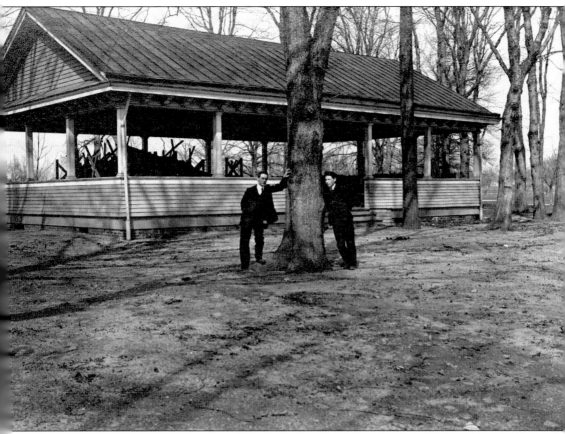

Two men pose in front of the pavilion in the heart of Knight Park in 1905. In the early part of the 20th century, the park became a preferred destination for local residents as well as visitors from Camden and Philadelphia. A wide range of cultural, social, religious, and athletic activities were held in the park, including church, school and family picnics, church services, community pageants, concerts, and baseball, football, and track events.

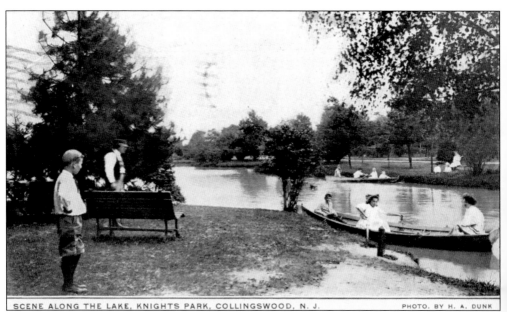

SCENE ALONG THE LAKE, KNIGHTS PARK, COLLINGSWOOD, N. J. PHOTO. BY H. A. DUNK

After Knight Park was dedicated in 1888, small lakes were constructed to replace a cedar swamp that originally stood at its center. Elaborate bridges and walks were built over the lakes to enhance the scenery, and boat landings were constructed along the shores to accommodate leisurely travel on the water. The drying up and stagnancy of the lakes in the late summer presented the only problems. (Below, courtesy of author's collection.)

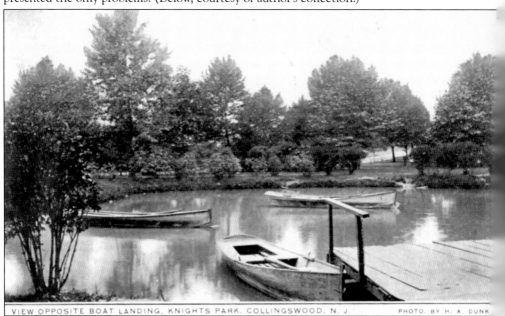

VIEW OPPOSITE BOAT LANDING, KNIGHTS PARK, COLLINGSWOOD, N. J. PHOTO. BY H. A. DUNK

The sole house standing in Knight Park was built as the superintendent's residence and clubhouse in 1888. The house was constructed by Andrew H. K. Doughty, an Atlantic City carpenter.

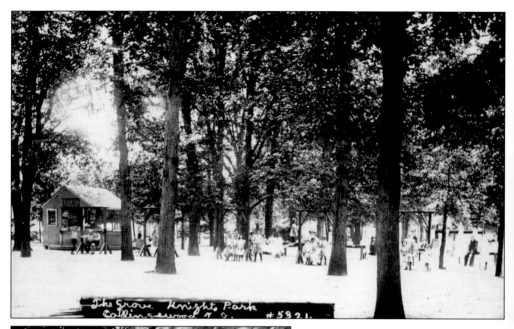

The Grove, Knight's Park, Collingswood, N. J. #5921.

In the early 1900s, the area surrounding the pavilion in Knight Park was known as "the Grove." Swings, hammocks, picnic tables, and a refreshment stand made the Grove a popular spot, particularly among the park's youngest visitors.

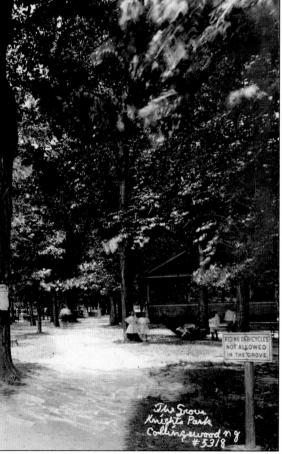

RIDING OF BICYCLES NOT ALLOWED IN THE GROVE

The Grove, Knights Park, Collingswood n j #5318

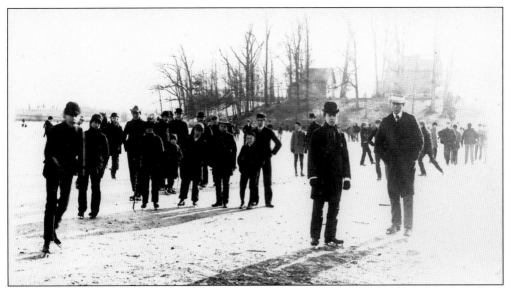

Men indulge in a popular Collingswood pastime, ice-skating on Newton Lake, at the beginning of the 20th century. At that time, ice-skating on both Newton Lake and Cooper River attracted thousands from Collingswood and the surrounding communities. Large bonfires were burned to provide warmth as well as lighting for the skaters.

This photograph was taken of Newton Creek from the foot of Colford Avenue in Collingswood. In the center of the creek, a man fishes off a canoe. Unlike Cooper River, Newton Creek was not used as a commercial waterway.

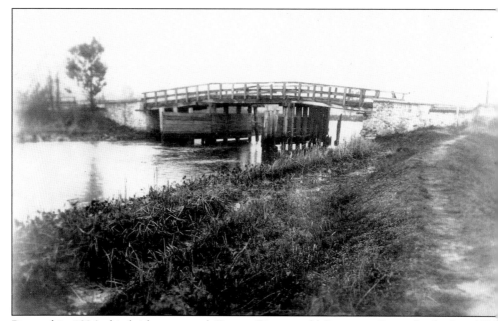

Pictured in 1896, this bridge spanned Cooper River at old Browning Lane. In the late 1800s, many of the farmers who lived near the creek utilized the waterway as an economical means of shipping their goods, such as produce, grain, and lumber, by small boats to Philadelphia.

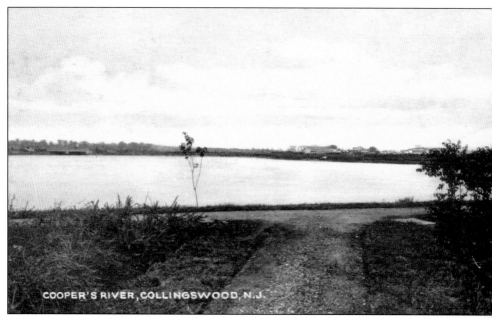

COOPER'S RIVER, COLLINGSWOOD, N.J.

At the time of Collingswood's incorporation, Cooper River, then known as Cooper's Creek, was a desirable location for recreational pursuits, particularly fishing, hunting, and ice-skating. In 1911, officials changed the name from Cooper's Creek to Cooper River, in hopes that a river would draw more federal financial assistance.

Four

STREETSCAPES

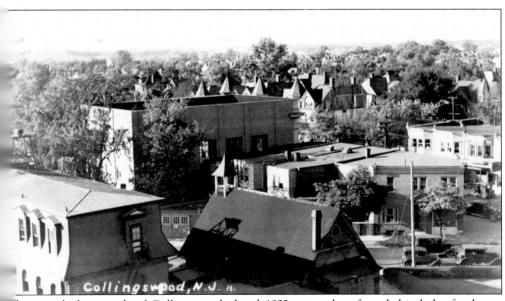

Collingswood, N.J.

This aerial photograph of Collingswood, dated 1932, was taken from behind the fire house on Collings Avenue, looking west past the Collingswood Trust Company building (later the Municipal Building) on Haddon Avenue, toward Philadelphia. The top of the old Holy Trinity Episcopal Church structure can be seen in the forefront of the photograph with the firehouse to its left.

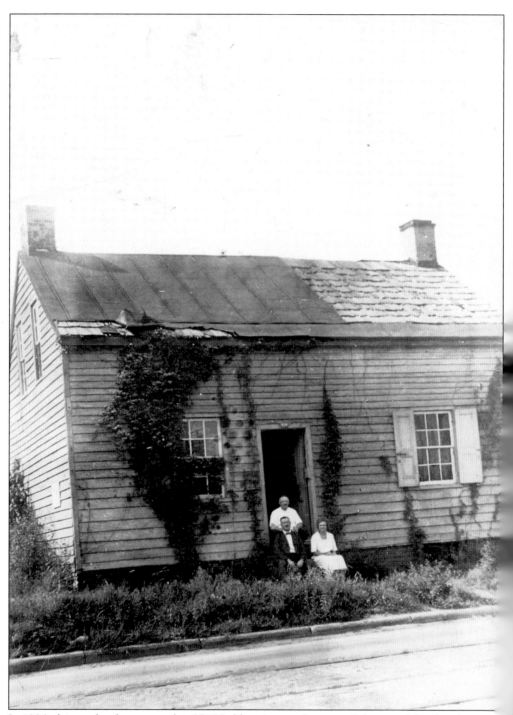

In 1886, this modest home stood at 354 Haddon Avenue between Palmer and Coulter Avenue. While a large portion of Haddon Avenue later would evolve into Collingswood's main commercial district, this section of the avenue, closer to Camden, would remain primarily residential.

Collingswood's first and only tavern was built in 1828 and was known as the Half-Way House. It stood at the corner of Haddon and Woodlawn Avenues, and also served as an inn for weary travelers. In 1873, the town cast a monumental vote to ban the sale of alcohol within its borders. However, the Half-Way House's proprietor at that time, Mahlon Van Booskirk, was reluctant to comply with the new ordinance, and was fined several times for violations. This photograph was taken of the Half-Way House during the blizzard of 1888.

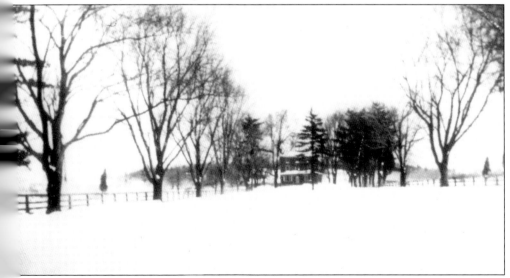

1850, William P. Tatem acquired 40 acres of farmland along Haddon Avenue. He and his family lived on the property in this farmhouse, which stood on what is now Maple Avenue, along a lane that would later become Frazier Avenue. At that time, hills and woods served as a picturesque backdrop. This photograph of the house was taken during the blizzard of 1888. (Courtesy of Keith Haberern.)

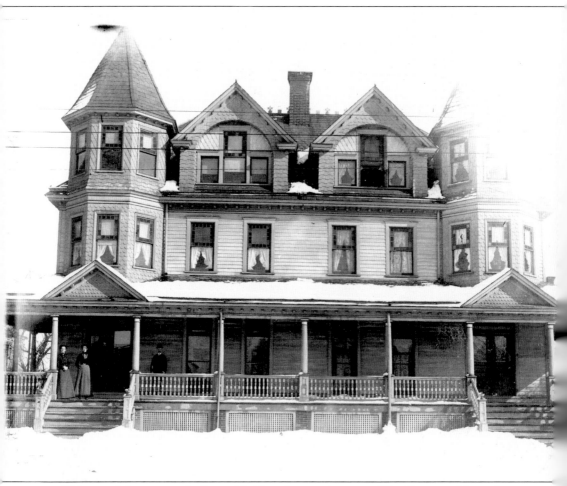

This grand house was built on Haddon Avenue between Woodlawn and Lincoln Avenue around 1892 by John Fleming. Fleming built a number of these palaces in Collingswood at that time period.

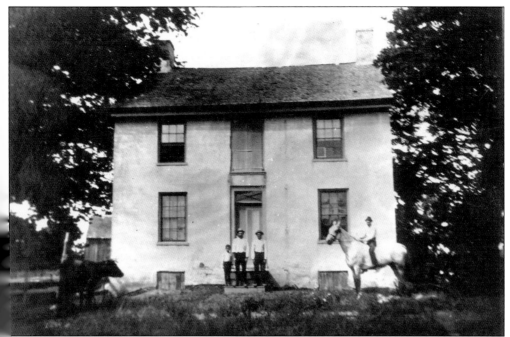

Shown in 1896, the Rowles' farmhouse, owned by Martha Rowles and located in the area of Knight and Highland Avenues, earned the moniker of the Pest House because victims of smallpox once were quarantined there during a tragic epidemic in 1902. A young physician, Dr. Edward S. Sheldon, attended to the inflicted. Dr. Sheldon would become one of Collingswood's most active and prominent citizens.

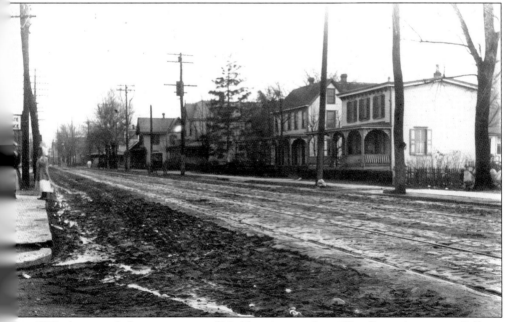

This 1902 photograph features a view of Haddon Avenue from Woodlawn Avenue to Collings Avenue. By 1904, this section of Haddon Avenue had begun its transformation from a residential ip to a commercial district.

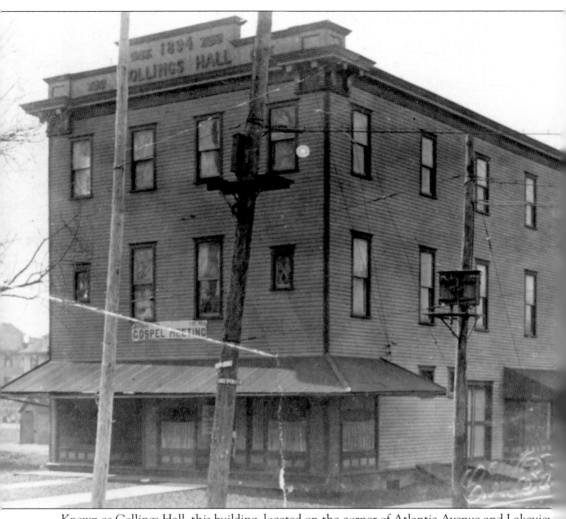

Known as Collings Hall, this building, located on the corner of Atlantic Avenue and Lakeview Drive, was built in 1894 and owned by Isaac Collings. The hall contained Shuster's Grocery Store on the first floor and the town's first basketball court on the second floor.

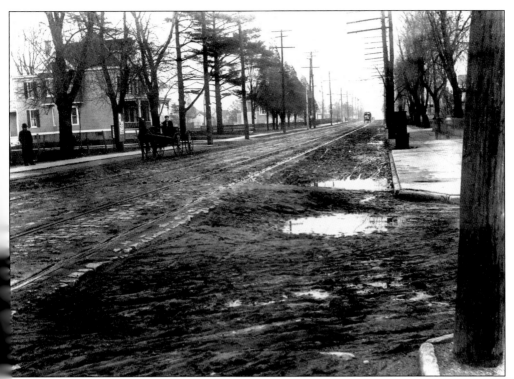

At the beginning of the 20th century, Haddon Avenue at Irvin Avenue was well traveled by trolleys and horse and buggies. It also was on the verge of a major commercial development at this time. By 1905, this section of Haddon Avenue would include Collingswood National Bank, Chamberlain's Pharmacy, and School No. 1.

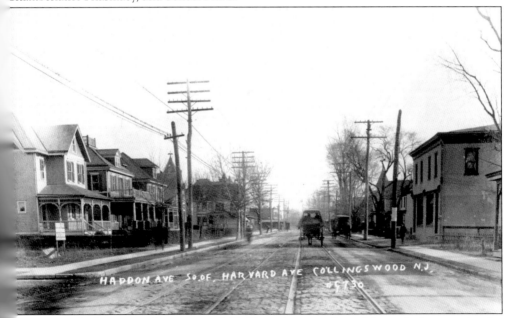

This postcard shows another view of Haddon Avenue, from Harvard Avenue, in the early 1900s.

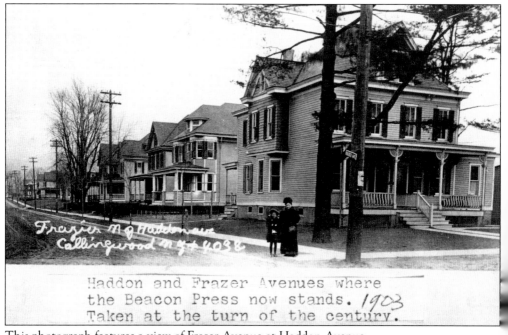

This photograph features a view of Frazer Avenue at Haddon Avenue.

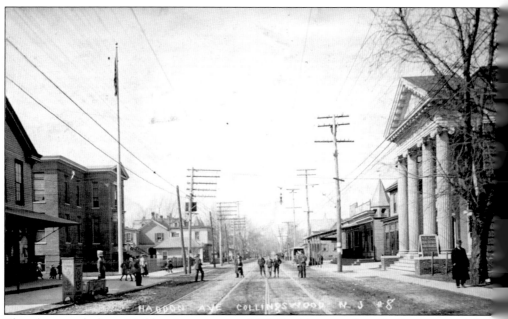

This photograph shows Haddon Avenue around 1908 looking west from Frazier Avenue. Schoo[l] No. 1 can be seen behind the flagpole at Irvin Avenue on the left-hand side, while Collingswoo[d] National Bank's Classical Revival–style building is on the right. At the time, School No. [1] students were told to be careful crossing Haddon Avenue, as the double-track trolley line, [as] well as a few automobiles, bicycles, and horse-drawn vehicles, made it a busy thoroughfare [of] its time.

At the end of the 1800s, Woodlawn Avenue was under construction from a farm lane to one of Collingswood's first residential streets.

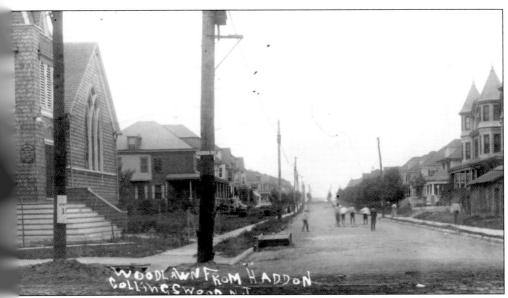

WOODLAWN FROM HADDON
Collingswood N.J.

y 1909, residential development had transformed Woodlawn Avenue from a farm lane to the ouse-lined avenue shown here. Note the original St. Paul's Evangelical Lutheran Church ilding shown in the left-hand corner of the photograph, at the corner of Haddon and oodlawn Avenues.

This real estate advertisement was placed by Newton B. T. Roney in the program book celebratin Collingswood's 20th anniversary in 1908. During Collingswood's early development, Roney wa a major developer of both residential and commercial properties, including the first block c modern stores on Haddon Avenue between Roney and Lincoln Avenues and the town's firs brick double homes on Roney Avenue. Residents did not like the name Roney Avenue an successfully petitioned to have it changed to Collings Avenue.

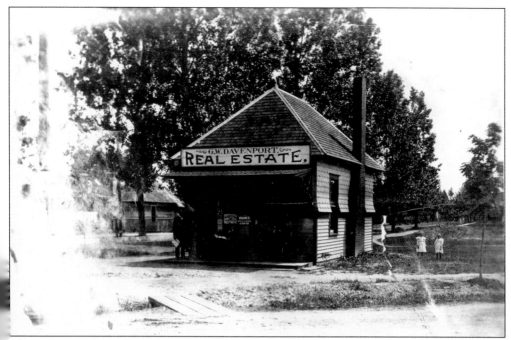

The real estate office of George W. Davenport, photographed in 1905, stood at Collings Avenue and Lakeview Drive. Davenport must have had a booming business at the time, as Collingswood's population grew rapidly from approximately 1,600 in 1902 to almost 5,000 in 1910.

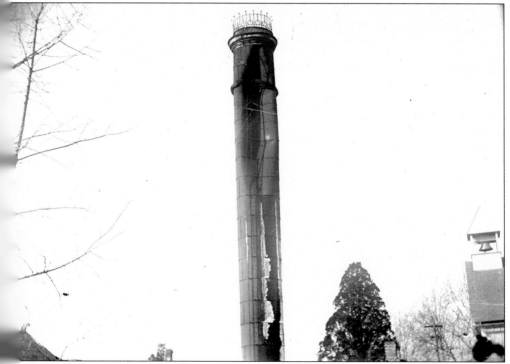

1900, this old water standpipe, located on Collings Avenue near Haddon Avenue, froze at the p and split in the middle. It later collapsed.

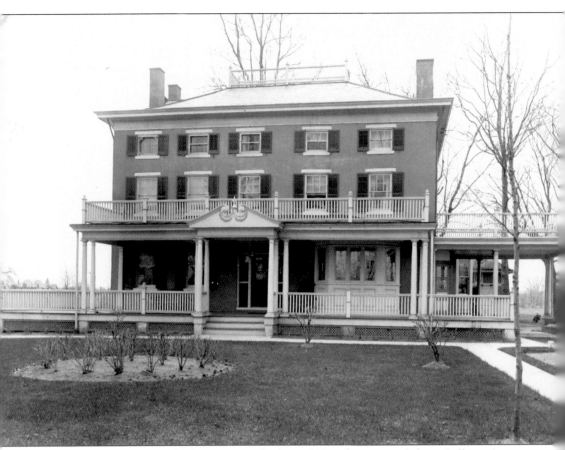

This home, photographed in 1909, was built in 1801 and once stood along Collings Avenue near Maple Lane. It was occupied for many years by Anna Maria Collings, Joseph C. Collings (who inherited the site from his father), and their 14 children.

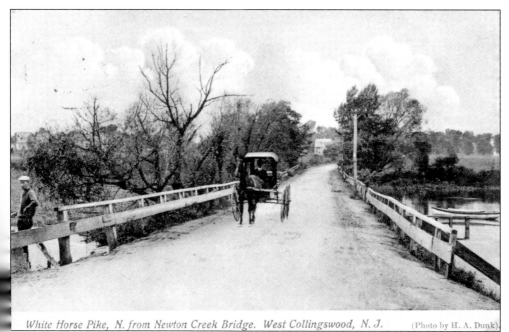

White Horse Pike, N. from Newton Creek Bridge. West Collingswood, N. J. (Photo by H. A. Dunk).

A postcard dated 1909 depicts a horse and buggy traveling down the White Horse Pike, north from Newton Creek Bridge, in West Collingswood. The well-traveled road extended from the Delaware River to the Atlantic Coast and was Camden County's first major toll-free road. Horse and buggies such as this one soon would share the road with a new form of transportation—the automobile.

This photograph was taken in 1939 looking toward the White Horse Pike. Nearly 10 years later, the Park View Apartments were constructed on this site.

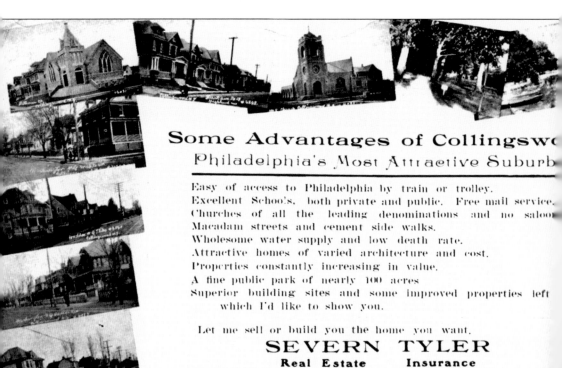

Some Advantages of Collingswo

Philadelphia's Most Attractive Suburb

Easy of access to Philadelphia by train or trolley.
Excellent Schools, both private and public. Free mail service.
Churches of all the leading denominations and no saloo
Macadam streets and cement side walks.
Wholesome water supply and low death rate.
Attractive homes of varied architecture and cost.
Properties constantly increasing in value.
A fine public park of nearly 100 acres
Superior building sites and some improved properties left
 which I'd like to show you.

Let me sell or build you the home you want.

SEVERN TYLER

| Real Estate | Insurance |
| Loans | Mortgages |

745 Park Ave., Collingswood, I

Postmarked 1909, this postcard advertised Collingswood as "Philadelphia's Most Attractive Suburb" to potential homebuyers, citing its excellent schools, churches, no saloons, and "wholesome water supply and low death rate."

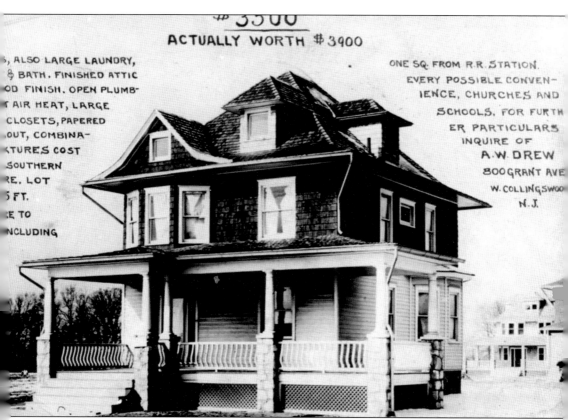

ACTUALLY WORTH $3900

, ALSO LARGE LAUNDRY,
& BATH. FINISHED ATTIC
OD FINISH. OPEN PLUMB-
AIR HEAT, LARGE
CLOSETS, PAPERED
OUT, COMBINA-
TURES COST
SOUTHERN
RE. LOT
5 FT.
E TO
NCLUDING

ONE SQ. FROM R.R. STATION.
EVERY POSSIBLE CONVEN-
IENCE, CHURCHES AND
SCHOOLS. FOR FURTH
ER PARTICULARS
INQUIRE OF
A. W. DREW
800 GRANT AVE
W. COLLINGSWOO
N. J.

Dated 1910, this real estate advertisement featured a house at 1115 Eldridge Avenue in Collingswood, with an asking price of $3,500. The advertisement touted the home's proximity to the Camden and Atlantic Railroad station as well as the town's churches and schools.

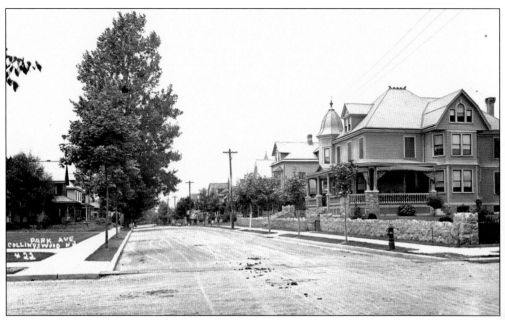

Park Avenue around 1908 was lined with some of Collingswood's largest and most elaborate homes, many of which still stand today.

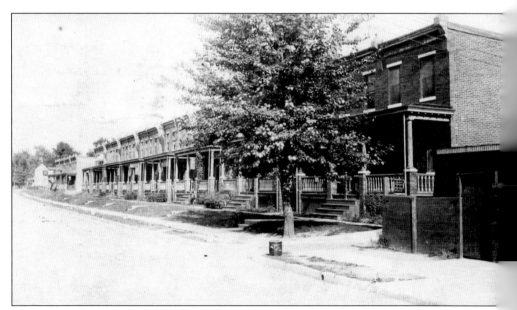

This postcard, postmarked 1913, features Lincoln Avenue between Haddon and Maple Avenue. Its brick row homes appear much as they do today.

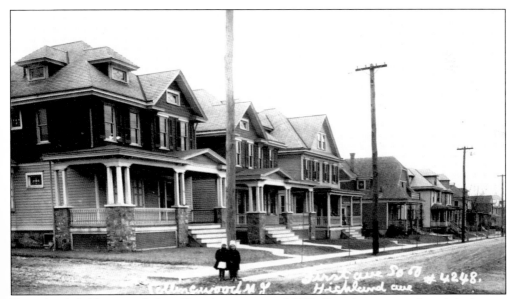

Two school children stand along First Avenue around 1922. First Avenue was the original name of Harvard Avenue. The next streets over from Harvard Avenue, Knight and Madison, were then known as Second and Third Avenues, respectively.

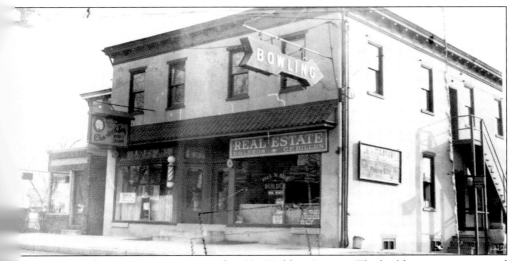

Harry Rice's real estate agency once stood at 634 Haddon Avenue. The building was constructed by Harry's son Paul W. Rice, who also built a bowling alley behind it.

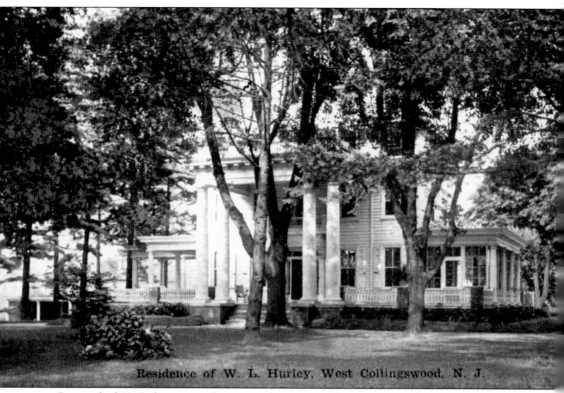

Residence of W. L. Hurley, West Collingswood, N. J.

Postmarked 1916, this postcard captures the image of Dungarvan, William L. Hurley's sprawling residence at 315 White Horse Pike in West Collingswood. The owner of Camden's largest department store, Hurley purchased the estate in 1909 from Dr. William Albert Davis and named it Dungarvan in honor of his place of birth in Ireland. Following Hurley's death, Dungarvan, which originally was constructed in 1850 by Isaac Collings, was purchased by the Excelsior Scottish Rite Bodies in 1930 for $125,000.

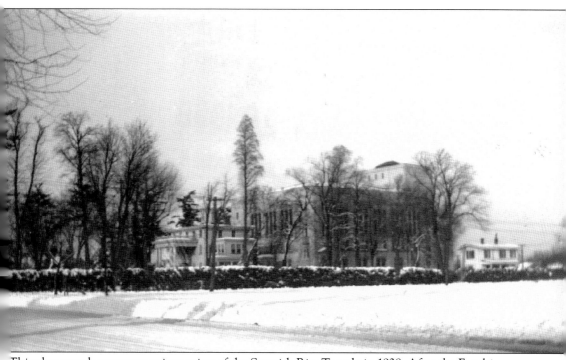

This photograph captures a wintry view of the Scottish Rite Temple in 1938. After the Excelsior Scottish Rite Bodies purchased Dungarvan in 1930, construction began on the large auditorium to the rear of the mansion. It was dedicated on October 3, 1931. The Excelsior Scottish Rite Bodies also undertook a major renovation to Dungarvan to create administrative offices and other facilities for the organization inside the mansion. (Courtesy of Sandra Powell.)

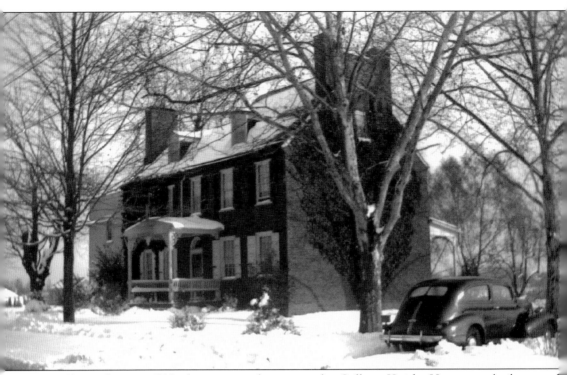

Shown here in 1938, the structure known as the Collings-Knight House was built around 1824–1827 by Edward Z. Collings II, a fifth-generation descendent of Robert Zane, one of the six original settlers of the area to later become Collingswood. The house was last privately owned by Charles H. Chase, who in 1967 bequeathed the property to the Borough of Collingswood in perpetuity as a public historic shrine. Today, the Friends of the Collings-Knight Homestead oversee and maintain the property and host events and educational programs at the home. (Courtesy of Sandra Powell.)

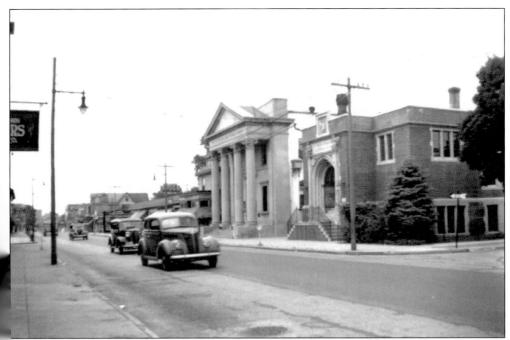

Automobiles travel down Haddon Avenue toward Haddon Township in 1938. Shown is the intersection of Haddon and Frazier Avenues, with the Collingswood Public Library's Carnegie Library Building standing on the corner. (Courtesy of Sandra Powell.)

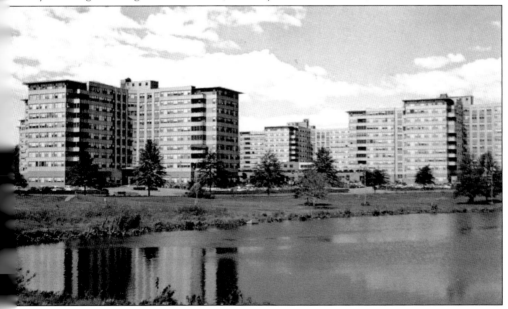

Collingswood Mayor Arthur E. Armitage, who served in the position of mayor for more than 50 years, made a now well-known observation in the 1940s that the town had no more room for horizontal growth and that the only way to accommodate an increasing population was to build upward. To that end, the Park View Apartments were constructed in 1948, becoming one of the first high-rise developments in the area. With this construction, Collingswood gained approximately 1,000 new residents.

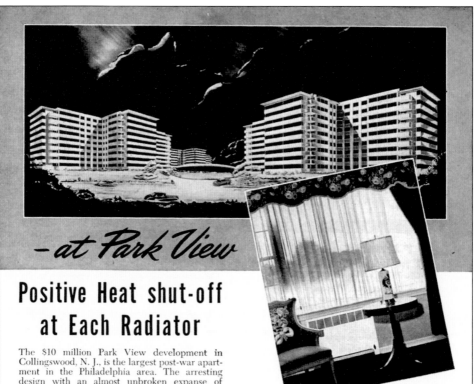

Positive Heat shut-off at Each Radiator

The $10 million Park View development in Collingswood, N. J., is the largest post-war apartment in the Philadelphia area. The arresting design with an almost unbroken expanse of window space has won professional acclaim. Television, radio and newspaper promotions have brought thousands to the model apartment.

The owners of Park View put comfort first. They provided a "Controlled-by-the-Weather" Webster Moderator System of Steam Heating. With fully recessed Webster System Radiation . . . Convector Radiators with built-in radiator trap and valve. Each radiator has a convenient, accessible, easy to operate handle providing complete shut-off at tenants' convenience.

With the Webster Moderator System, heat is delivered continuously — plenty of heat in really cold weather, mild heat for mild days. The supply of steam is varied automatically with changes in the weather. There's a Webster Radiator Valve for 100% heat shut-off from each radiator — no dampers are needed.

Park View is owned by Sylvester A. and Sylvester

Park View interior showing Webster System Radiator. Flush-with-wall, takes no useable room space. Metal front provides easy access if necessary. Convenient, quick shut-off handle.

J. Lowery. The Builders are S. J. Lowery and E. J. Frankel. The architects were J. Raymond Knopf and Samuel J. Oshiver (associate). Engineers included Robert E. McLoughlin, Salvatore S. Guzzardi, and Robertson & Johnson. The heating contractor was Benjamin Lessner Co., Inc.

Park View was financed through County Trust Co., Tarrytown, N. Y., with the Seaman's Bank for Savings of New York as permanent mortgagee. It is insured by FHA.

For information, address Dept. AR-8

WARREN WEBSTER & COMPANY
Camden 5, N. J. Representatives in Principal U. S. Cities
In Canada, Darling Brothers, Limited, Montreal

WEBSTER
MODERATOR
SYSTEM
OF STEAM HEATING
"Controlled by the weather"

This advertisement for the Park View Apartments development and its "Controlled-by-the-Weather" Webster Moderator System of Steam Heating was featured in the August 1950 issue of *Architectural Record* magazine. The advertisement proclaimed, "The $10 million Park View development in Collingswood, N.J., is the largest post-war apartment in the Philadelphia area. The arresting design with an almost unbroken expanse of window space has won professional acclaim." (Courtesy author's collection.)

Five

SCHOOL TIES

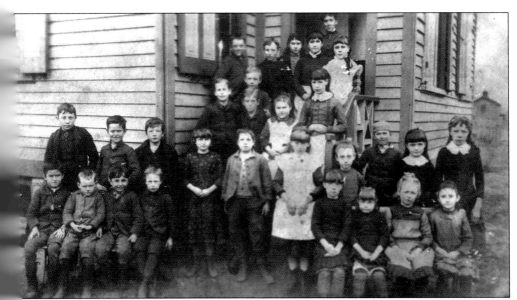

The Collingswood School was built in 1882 on the site of the current James A. Garfield Elementary School at a cost of $3,000. In this photograph, students gather outside of the school in 1886. A few years later, in 1889, a four-room addition was added to the front of the building.

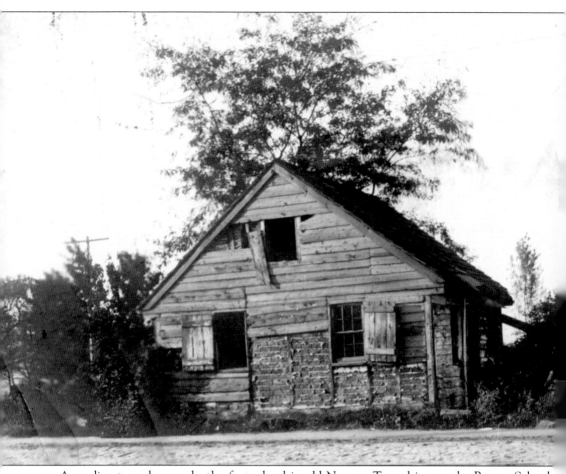

According to early records, the first school in old Newton Township was the Barton School, built in 1789. It was located at 566 Haddon Avenue, near East Knight Avenue. This photograph shows the building around 1907.

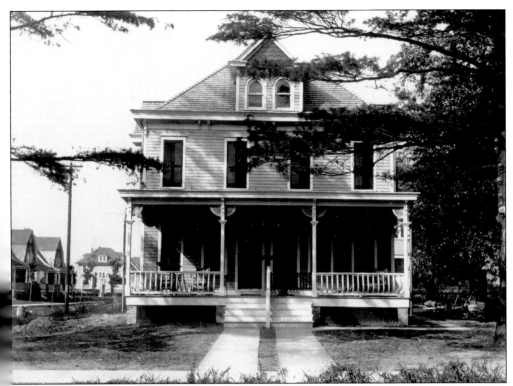

As Collingswood rapidly expanded at the beginning of the 20th century, the Collingswood School could no longer accommodate all of the town's school children. The town purchased the Nippe home, shown here, at Haddon and Irvin Avenues at a cost of $4,500, and converted it into School No. 1, later known as the Zane School. School No. 1 opened in 1905 along with School No. 2, later known as the Sharp School.

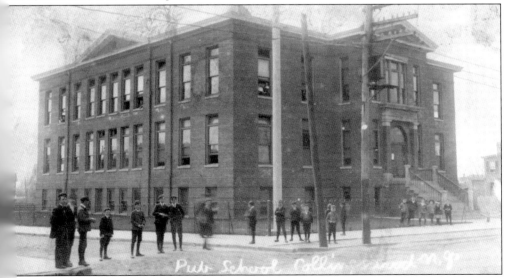

School children take a break from their studies in front of School No. 1. An iron fence surrounded the school, while a wooden fence in the rear of the school ran lengthwise to divide the schoolyard into a boys' yard and a girls' yard.

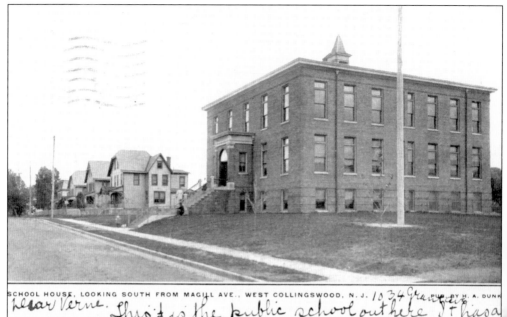

SCHOOL HOUSE, LOOKING SOUTH FROM MAGILL AVE., WEST COLLINGSWOOD, N.J. *1034 Gra...* PUB BY H. A. DUNK

Lesar Verne. This i is the public school out here Ithaca

In 1905, the new School No. 2 was completed at Magill and Comley Avenues in West Collingwood. The elementary school later was renamed after Thomas Sharp, one of the area's first settlers, who arrived in New Jersey from Britian in 1681.

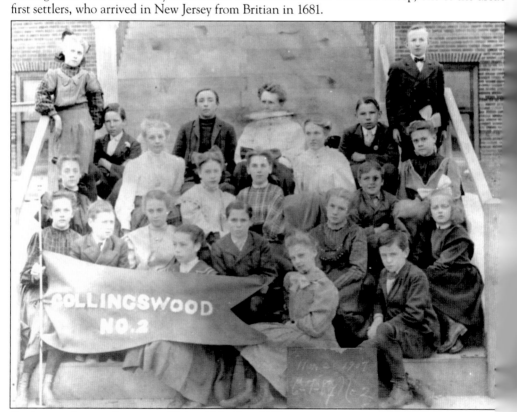

Students gather on the steps of School No. 2 in 1907.

72

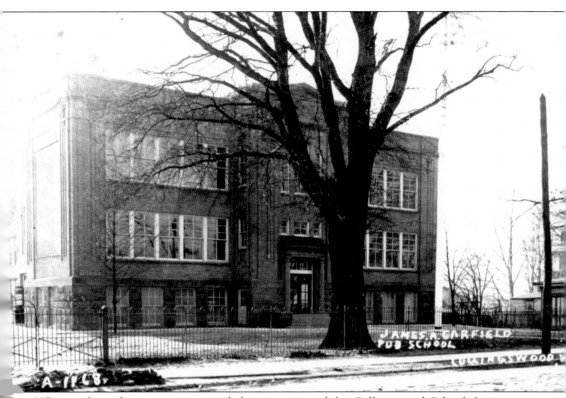

In 1907, growth in the town necessitated the reopening of the Collingswood School. It was renamed the James A. Garfield Elementary School after the 20th president, who served for a little more than six months in 1881 before he was assassinated.

As Collingswood's population increased to nearly 5,000 in 1910, two additional schools were erected: the William P. Tatem School, shown here, on Lincoln Avenue, and the North School on Stokes Avenue.

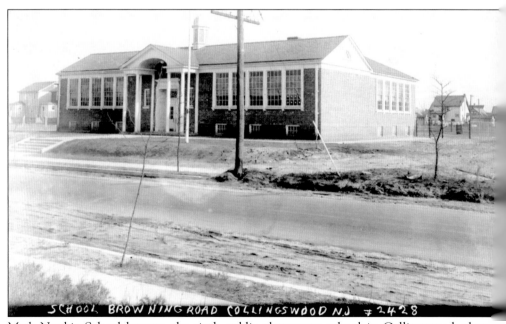

SCHOOL BROWNING ROAD COLLINGSWOOD NJ #2428

Mark Newbie School became the sixth public elementary school in Collingswood when opened in 1924 on Browning Road.

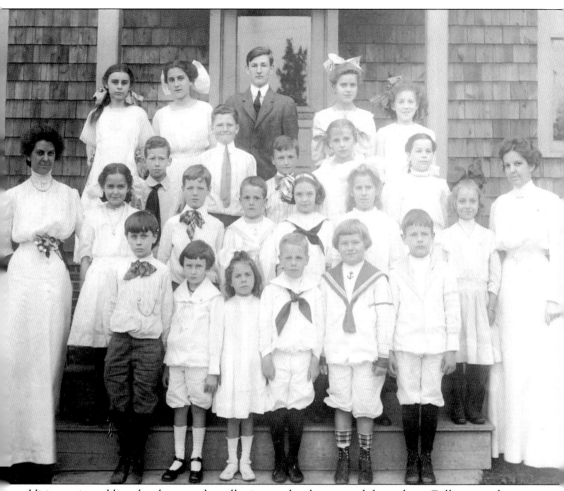

In addition to its public schools, several small private schools operated throughout Collingswood in its early years, including the Misses Thomas School, shown here, on Lakeview Drive.

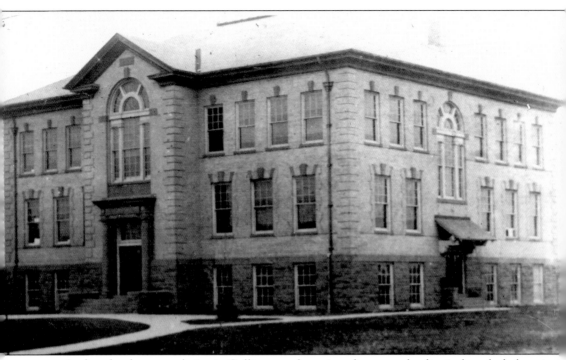

As the school-age population in Collingswood continued to grow, the district board of education established a high school program in 1906. Initially, it was housed in School No. 1 and the Collingswood School. In 1910, the first Collingswood High School graduating class held its commencement in the new, yet unfinished E. C. Knight High School on Collings Avenue. The following September, all high school classes started in the new building.

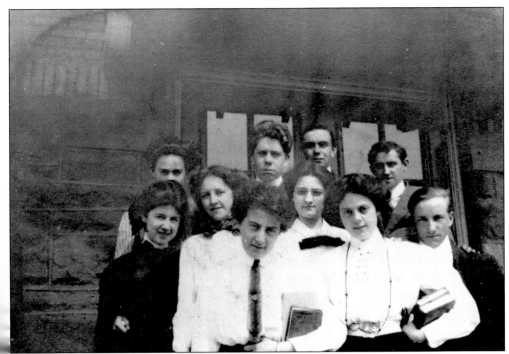

This photograph was taken of Collingswood High School students in chemistry class in 1911. It was included in the scrapbook of fellow student Helen P. Westcott, which was donated to the Collingswood Public Library.

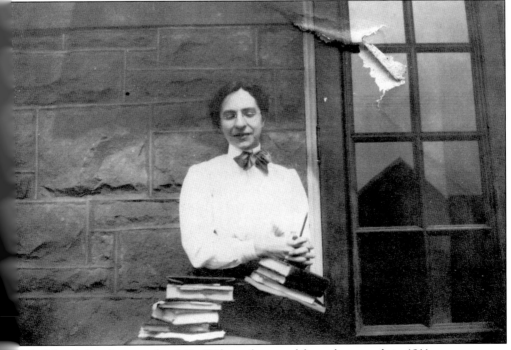

High School chemistry teacher Miss Wilson also posed for a photograph in 1911.

A student stands behind the high school in September 1918, before the junior high school was built there.

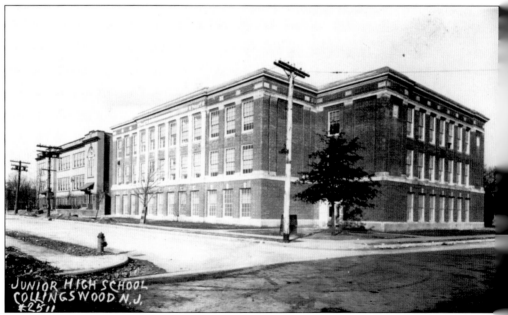

In 1924, Collingswood Junior High School was built behind the high school and opened for students in grades seven, eight, and nine. In the late 1980s, ninth-grade students relocated to the high school, and the school was renamed the Collingswood Middle School.

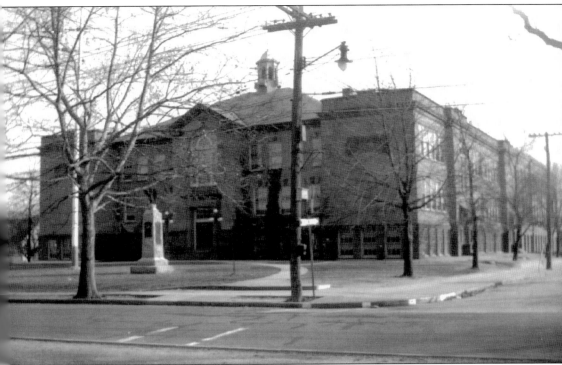

This later photograph of E. C. Knight High School in 1939 shows the building with wings added to each side of the original structure and the World War I monument on the front lawn. After a new, larger high school was built on the opposite corner in 1963, this building was demolished, and the World War I monument relocated to Knight Park. The Ben Mark Gymnasium, which serves the middle school students, now stands on the site of the old high school. (Courtesy of Sandra Powell.)

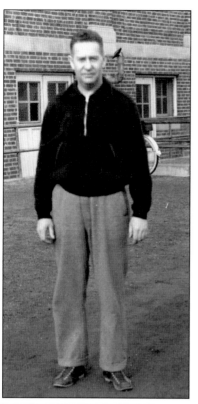

Howard T. "Skeets" Irvine served Collingswood High School as physical education teacher, athletic director, and coach from 1919 until his death in 1948. While he successfully coached several sports, including baseball, basketball, and track, it was Collingswood High School's football program that he elevated to legendary status. During his tenure, he coached the Panthers to 223 football victories and 16 championships.

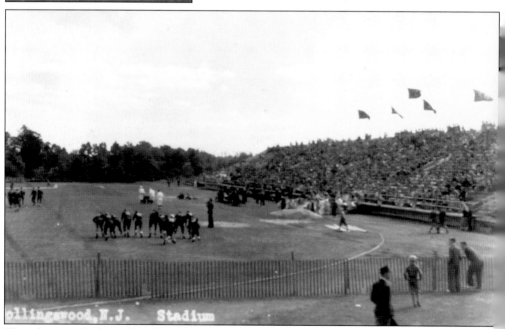

This photograph shows Shields Field, the Collingswood High School sports field and stadium during a Collingswood High School football game. The athletic field was named after Robert Shields, a young Collingswood resident who was tragically killed during the Battle at Belleau Wood in World War I. In 1931, the field was enlarged, and the concrete stadium was erected.

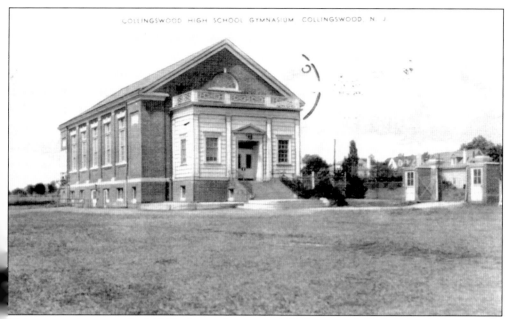

This postcard, postmarked 1949, shows the original Collingswood High School Gymnasium. The gym featured bleachers that lined the perimeter of the building near the ceiling, so fans would look over a railing and down on the action on the court below. A new gymnasium was built in 1951 and dedicated as the Howard T. "Skeets" Irvine Gymnasium in honor of the great coach. (Courtesy of author's collection.)

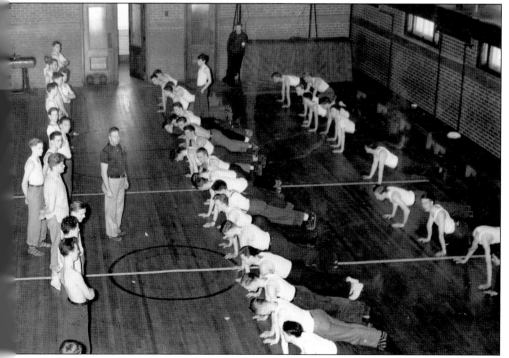

…vine oversees a physical education class in the Collingswood High School Gymnasium … 1938.

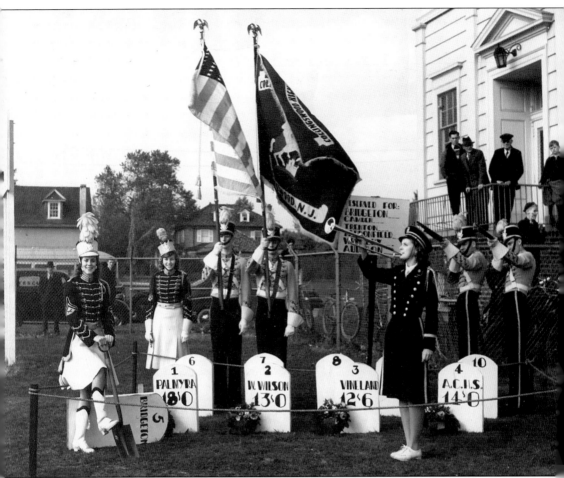

Behind what was then the Collingswood High School Gymnasium, drum major Martha Ann Merchant (left) digs a grave for defeated Bridgeton's football team, the latest "victim" of the Collingswood Panthers, in 1940. Dorothy Taylor, standing at right, blows a mournful taps as (from left to right, next to Merchant) Ruth Miller, Bob Null, and Dick Stapleton stand guard. The Panthers football team would finish with an impressive 9-1 record that year.

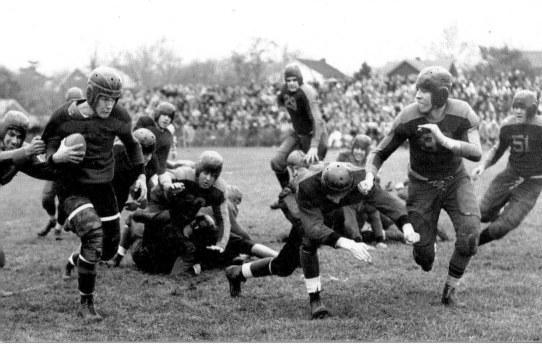

ny Yanelli, left end for the Collingswood football team, bites his tongue as he slows down
rry Rockwell of Haddonfield. The game, held on November 13, 1943, at Collingswood's
ields Field, resulted in a 13-0 win for the Collingswood Panthers.

COLLINGSWOOD HIGH SCHOOL
RECORD OF FOOTBALL TEAMS 1909-1958

	YEAR	WON	LOST	TIED		CAPTAIN
	1909	1	–	–	other games, scores unknown	none
	1910	1	1	1	other games, scores unknown	Al Usilton
	1911	5	2	0		Lloyd Haney
	1912	5	5	0		Harold Nace
	1913	2	2	1		Royal Smith
	1914	–	2	–	other games, scores unknown	Ray Williams
	1915	1	6	2		P."Shorty"Brauer
	1916	3	4	0		Claude Campbell
	1917	–	–	–	no records	
	1918	1	4	1		Harold Anderson
	1919	5	2	1	(Skeets Irvine's 1st year)	Bugs Brierly
*	1920	9	1	0	Class B Champs	Eggs Warren
*	1921	7	2	1	Class B Champs with Woodbury	Eggs Warren
*	1922	8	2	0	Class B Champs	Bob Wilkens
RU	1923	8	2	0		Bob Wilkens
	1924	5	5	0		Pud Morris
RU	1925	9	1	0		Cliff Rubicam
*	1926	8	0	1	Class A Champs	Oz Minot
RU	1927	7	1	1		Rosy Young
*	1928	8	1	0		Al Minot
*	1929	8	0	2	Class A Champs	Bill Willard
RU	1930	6	1	2	Best defensive record – only 12 points scored upon team	El Downs
*	1931	10	0	0	State Championship, Best offensive record – 286 points	Jack Eerle
*	1932	9	0	0	Group IV Champs – 23 straight wins at end of season	Bob Schuenemann
RU	1933	8	2	0	28 straight wins going into the Camden game	Charley Sink
*	1934	10	✗1	0	Group IV Champs –lost to Bloomfield in State Championship game	Walt Reinhard
*	1935	9	1	0	Group IV Champs with Vineland and Camden	Bis Bisbing
*	1936	7	2	1	Group IV Champs	no captain
	1937	4	6	1		Jim Spillane
*	1938	9	0	1	Group IV Champs	John Wurster
RU	1939	8	2	0	(heaviest team)	Guy Vance
*	1940	9	1	0	Group IV Champs	Joe Brosic
	1941	5	4	1		Joe Jones
*	1942	9	✗1	0	Group IV Champs –lost to Bloomfield in State Championship game	Fred Boehm
	1943	5	5	0		Hank Rossell
	1944	4	5	1		Biffer Bozarth
*	1945	8	1	1	GroupIV Champs with Camden	Joe Hinger
*	1946	9	1	0	Group IV Champs–252 points scored,2nd highest	Mike D'Alessandro & W.Fingerhut
	1947	3	5	2		Mike Moffa & Ray Narleski
*	1948	10	0	0	Group IV Champs	Ted Narleski
*	1949	7	3	0	Group IV Champs,	Ed Schenkin & LarrySchuman
	1950	3	4	1		Fred Krum
RU	1951	6	2	1		Gene Capinas,Robert Ford,Rob Hoover
	1952	4	3	2		Ronald Schmoll,Robert Dick
	1953	3	5	0		Howard Birchmier
RU	1954	5	2	2		Joe Bieksia
	1955	2	7	0		Cliff Rubicam Jr.
	1956	2	7	0		Bill Hicks
	1957	4	3	2		Herb Gerstein
*	1958	9	0	0	Group IV Champs	Lew Sweigart
	1959					

19 CHAMPIONSHIPS including
one STATE CHAMPIONSHIP
BEST RECORD IN THE STATE

* – championship won
RU – indicates Runner-up
✗ – lost to Bloomfield in post-season games, 1934 & 1942

This sheet shows the records of Collingswood's football teams from 1909 to 1958. The sheet w
included in Howard T. "Skeets" Irvine's extensive scrapbook, maintained after his death ar
now kept in the Collingswood Public Library.

Six

SERVING THE PUBLIC

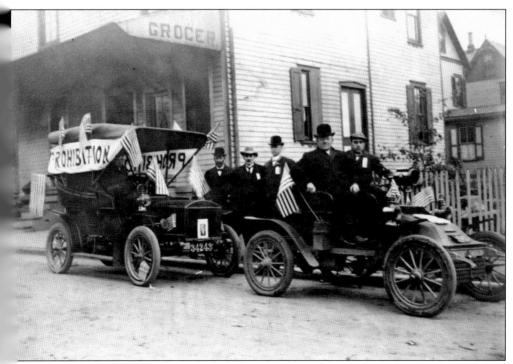

In 1906, a Prohibition parade was held in support of anti-drinking laws. Pictured, from left to right, are: Joseph Mathis, Mayor George Lippincott, W. B. Woodrow, Dr. Edward S. Sheldon, and Rev. J. Mason.

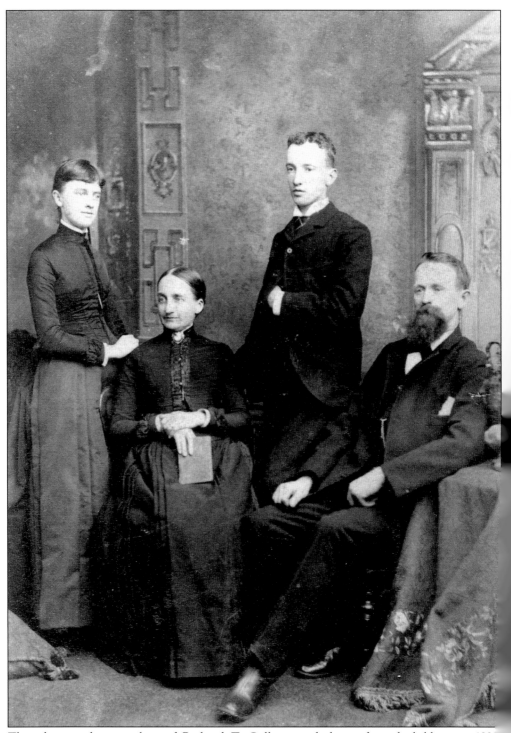

This photograph was taken of Richard T. Collings with his wife and children in 1898. Richard T. Collings, one of the town's founding fathers, served as mayor in the late 1800s and again in 1908.

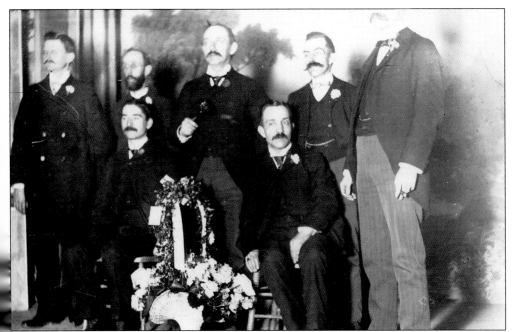

In 1896, a new borough act converted Collingswood from a commission form of government to a mayor and council form of government. As a result of this act, the borough's first council was formed and members included, from left to right, (first row) John Flynn and Sam Magill; (second row) W. B. Woodruff, Harry Smith, Henry R. Tatem, Frank Byam, and Frank North. Under the new government, Henry R. Tatem became the town's first popularly elected mayor. In 1917, the borough converted back to a commission form of government.

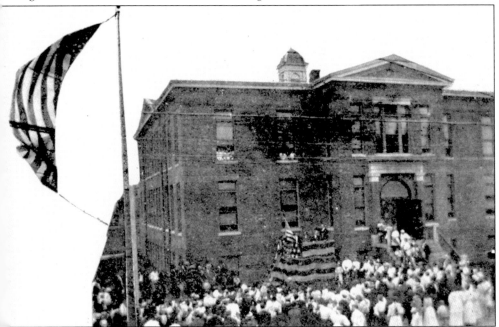

Collingswood residents celebrated Labor Day 1906 with a flag-raising ceremony outside of School No. 1.

PROGRAM

Twentieth Anniversary, Collingswood, N. J.

Friday, October 2, 1908

Afternoon. At the Band Stand in the Knight Park.

12.30 to 1.30 P. M. Luncheon to invited guests.

2 P. M. Municipal Exercises. Mayor Richard T. Collings presiding.

1. Music..........Kendle's First Regiment Band, Philadelphia
2. InvocationRev. John R. Mason
3. Singing Patriotic Song.........................School Children
4. Brief Historical Sketch.................J. Fithian Tatem, Esq.
5. Music ...School Children
6. Words of Greeting........................Hon. Howard Carrow
7. Music.
8. Address..............................Governor J. Franklin Fort
9. Singing "America".................................led by Band
10. Patriotic Airs..................................by Band

Following the exercises, visitors are cordially invited to inspect "The Knight Park" and view the elaborate decorations of many homes in all parts of the Borough.

The Hospitality Committee will be pleased to extend every courtesy to visitors.

Friday Night, October 2, 1908

ANNIVERSARY PARADE—Mr. James B. Rutter, *Marshall*

This attractive feature will be composed of fire companies of this vicinity, lodges, societies, historical floats, comic features, bands of music.

Route of parade: Form on Massey Avenue, march to Collings, to Haddon, to Homestead, to Oriental, to Stiles, to Haddon, to Lees, to Park, to Collings, to Champion, to Grant, to Browning Road, to Zane, to Haddon, to Second, to Maple, to Woodlawn, to Haddon, to Collings, to Fire House and dismiss.

The Committee requests all places of business and all residences to display the Borough colors—Blue and White; American Flags, Lanterns, or whatever their taste dictates, to show their loyalty and patriotism.

For the best day decorations in East and West Collingswood, 5 x 8 flags will be awarded as prizes. The same kind of flags will be given for the best night decorations.

Collingswood's 20th anniversary was a reason to celebrate, and on the first weekend of October in 1908, the town threw a grand gala to commemorate its incorporation. A three-page program of the celebration documented the festivities, which included an address by New Jersey governor J. Franklin Fort to a crowd gathered in Knight Park, as well as a lavish parade. As noted at the bottom of the first page of the program, shown here, residents also were asked to decorate their homes and businesses in borough colors, blue and white, and with American flags, to show their loyalty and patriotism.

6 Pieces Assorted Fancy Rockets —6 pounds.

6 Pieces Assorted Fancy Rockets —8 pounds.

2 Pieces Mammoth Fancy Rockets —12 pounds.

2 Pieces Five Break Repeating Rockets—12 pounds.

FLYING GIRONDOLAS.

3 Pieces. Fired from posts, arising in the air and giving a brilliant, revolving, cascade effect.

20TH CENTURY NIGHT BOMB-SHELLS.

2 Pieces 1 Break Shell—6-inch.
2 Pieces 2 Break Shell—6-inch.
2 Pieces 3 Break Shell—6-inch.
2 Pieces 1 Break Shell—9-inch.
2 Pieces 2 Break Shell—9-inch.
2 Pieces 3 Break Shell—9-inch.
12 Pieces 1 Break Shell—12-inch.
6 Pieces 2 Break Shell—12-inch.
6 Pieces 3 Break Shell—12-inch.
3 Pieces 5 Break Shell—12-inch.
2 Pieces 1 Break Shell—18-inch.
1 Piece 3 Break Shell—18-inch.

These shells are the grandest production of the Pyrotechnic Art. They show every known color, and all the beautiful combinations of colors, besides streamers, shooting stars, meteors, comets, duration stars, serpents, gold rain, trailed stars, whirligigs, parachutes, mammoth spreaders, etc.

GROUND PIECES.

2 Pieces Special Saucisson Mines.
2 Pieces Extra Large Mines No. 10.
1 Piece Mammoth Mines No. 12.
2 Pieces Mammoth Jack in Box.
2 Pieces Mammoth Dragon Nests.
2 Pieces Mammoth Devil Among Tailors.

These pieces are fired from the ground, and on exploding give varied and novel effects.

SET PIECES.

Good-night—With Gatling Salute and Battery National Colors.

4 dozen bags red fire for brilliant illumination of grounds.

Total, 213 pieces.

Sunday, October 4, 1908

3.45 o'clock, near Band Stand in Park. (In case of rain this will be at First M. E. Church.) Union Song Service, with massed choirs of all churches, under the direction of H. L. Veatch and J. B. Riggins.

Address by Rev. Edmund J. Kulp, pastor Broadway M. E. Church, Camden, N. J. Subject, "Civic Righteousness."

In addition to above services it is suggested that each church make some special reference to the Anniversary at the morning or evening services.

he 20th anniversary celebration ended on a religious note on Sunday, October 4, 1908. This nal page of the program detailed a performance of massed choirs of all the town's churches at a rvice held in Knight Park. The performance was followed by a sermon on civic righteousness ven by Rev. Edmund J. Kulp, pastor of Broadway M.E. Church in Camden.

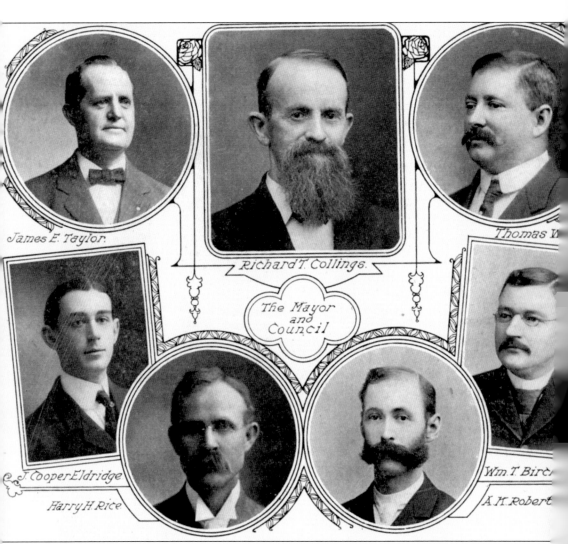

In 1908, the year of Collingswood's 20th anniversary, Richard T. Collings served as mayor. Hi council consisted of James E. Taylor, Thomas W. Jack, Cooper Eldridge, Harry H. Rice, William T Birch, and A. K. Roberts.

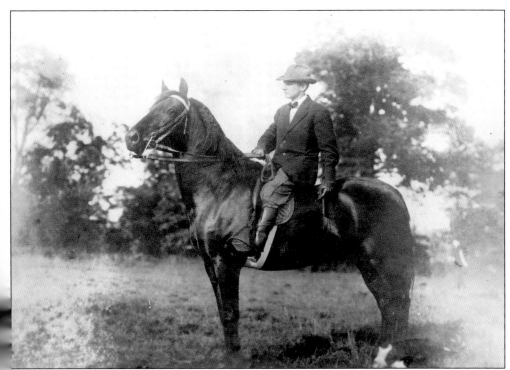

James R. Duff, astride his horse Major Bellmawr, marshaled all parades in Collingswood from 1908 until the 1930s. Duff, a long-time resident and shopkeeper, also was a local historian and photographer. Many of his photographs now are a part of the Collingswood Public Library's collection and are featured in this book.

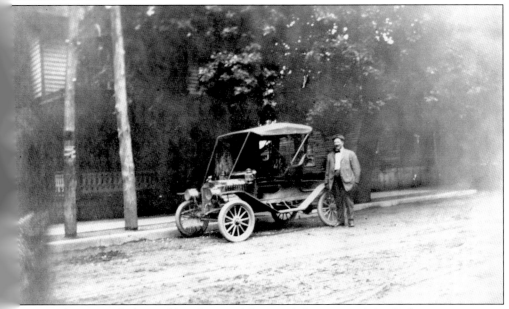

1902, Thomas W. Jack stood beside one of the town's first automobiles. Jack was a prominent ollingswood citizen who was very active in politics. He served on the borough council and later as elected mayor in 1920. He also served as Camden County sheriff.

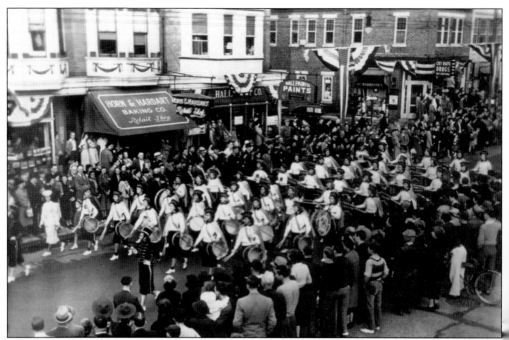

The grand parade, held on Saturday, October 1, 1938, was one of the opening-day events that began a nine-day celebration of the borough's 50th anniversary. The parade started at Cuthbert Road and proceeded down Haddon Avenue to Browning Road, to Magill Avenue to Richey Avenue, and to Collings Avenue. Participants in the parade included Collingswood's fire companies, National Guard units, Naval Reserve units, Collingswood Boy and Girl Scouts, Legion groups, borough leaders, and the Collingswood High School Drum and Bugle Corps.

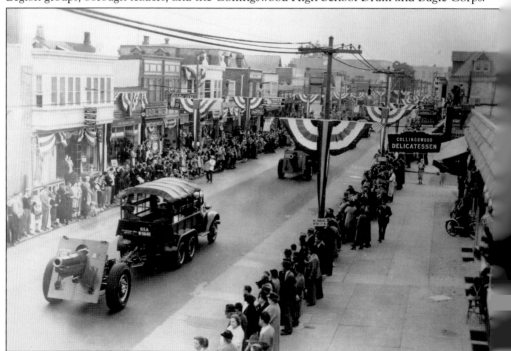

Program of Events

:urday, October 1st, 12.30 p. m., at Stadium—
 Football: Collingswood vs. South Philadelphia.

2.00 p. m.—Parade.

3.00 p. m.—Band Concert in front of Fire House.

nday, October 2nd—Special Services in all Churches.

»nday, October 3rd, at 8.00 p. m.—Community Night at Con-
 sistory Building, White Horse Pike. Governor A. Harry
 Moore, Guest Speaker.

esday and Wednesday, October 4th and 5th, 8.00 p. m.—
 HISTORICAL PAGEANT—at Stadium.

ursday, October 6th, Afternoon, American Legion Hall—
 Fashion Show, sponsored by Women's Organizations.

ursday, October 6th, Evening — Merchants Night

lay, October 7th—Youth Activities.

irday, October 8th,
 12 Noon—Planting Trees, Newton Lake Park.
 2.00 p. m., at Stadium—
 Football: Collingswood vs. Vineland.

.30 p. m.—Banquet, honoring Old Timers, at Consistory,
 White Horse Pike. Former Governor Harold G. Hoffman,
 Speaker.

day, October 9th, Afternoon, at Stadium — Religious Ser-
 vices, sponsored by Churches of our Borough.

This program for Collingswood's 50th anniversary celebration in 1938 shows an extensive
tinerary of special events planned over a nine-day period in October. Highlights included a
community night at the Scottish Rite Consistory with New Jersey Governor A. Harry Moore
erving as guest speaker, and a historical pageant at the high school stadium, which included a
4-episode retelling of Collingswood's history.

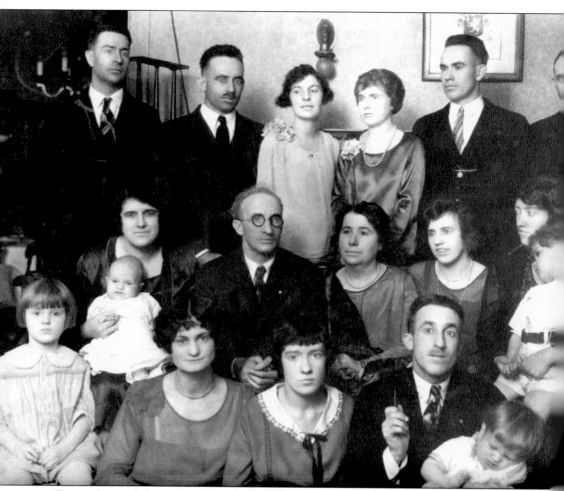

Descendants of the Collings family pose for this family portrait around 1920s. The Collings family, who were descendants of Robert Zane, one of the first original settlers of Newton Township in the 1680s, were major landowners in the area. By the late 1800s, Edward Collings Knight and his cousin Richard T. Collings were the principal developers of Collingswood. In 1881, 10 of the area's small population, including Richard T. Collings, J. Stokes Collings, Joseph E. Tatem, Chaukley Parker, and William R. Eldridge, gathered in the shoe shop of James Riggins and chose Collingswood as the name of their town, to honor this important family. Other names considered were Ogden and Rosedale. (Courtesy of F. A. Collings.)

At the time of Collingswood's incorporation in 1888, Chaukley Parker, left, and Sam Simons served as town constables. An official chief of police was not appointed until 1912.

the early 1920s, this small bungalow was erected to serve as Collingswood's police station. It as used by the police department until 1950, when the force moved into its current building on tlantic Avenue. (Courtesy of Sandra Powell.)

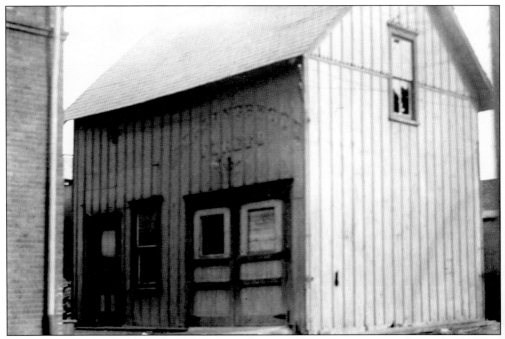

The original structure that housed the East Collingswood Fire Company was located at 20 West Collings Avenue, where the fire department still resides today. The site was purchased on April 16, 1895, shortly after the fire company was incorporated on March 7, 1895. The company's original membership included 24 prominent citizens, such as H. L. Merrick, Henry R. Tatem, and Chaukley Parker.

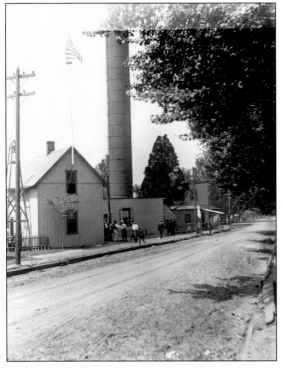

This photograph shows the firehouse of the East Collingswood Fire Company, flying the American flag, as it stood on Collings Avenue, then a simple dirt road at the beginning of the 20th century. A wooden fire tower with a fire bell stood to the left of the building.

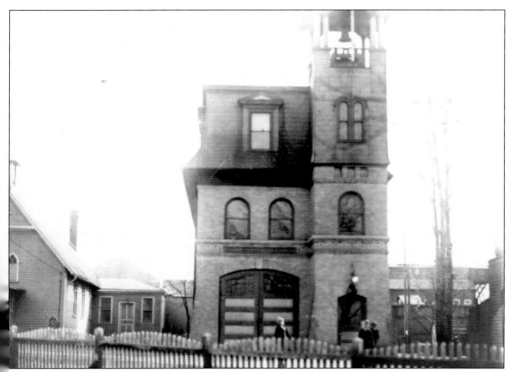

In the early 20th century, the East Collingswood Fire Company found the need for larger quarters and built this handsome new building, shown here in 1902, on Collings Avenue. In a program commemorating Collingswood's 20th anniversary in 1908, the fire company was noted as having "an up-to-date truck and a fine hose cart with latest design."

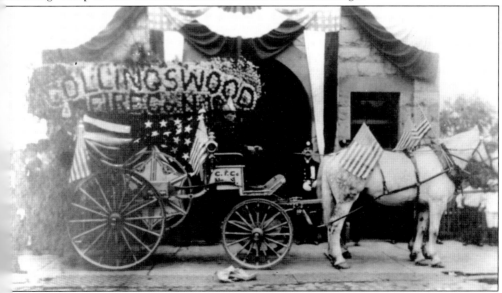

Henry Frech, owner of Frech's Hardware Emporium and Blacksmith Shop and one of the original members of the East Collingswood Fire Company, built Collingswood's first fire wagon, shown here in a parade in Mount Holly in 1904. The wagon worked well, but the horses struggled to pull it through the muddy, unrefined streets of that time period.

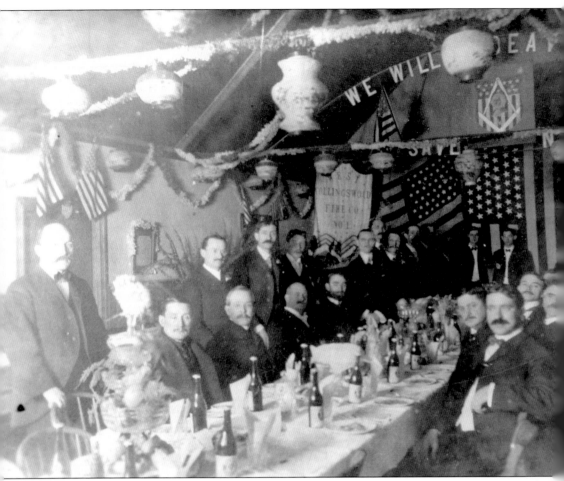

The West Collingswood Fire Company was photographed at a large banquet held upstairs in their Taylor Avenue firehouse around 1910. The West Collingswood association was incorporated on January 25, 1895. Charter members included familiar names such as Thomas Cattell, J. Z. Collings, and Cooper Eldridge. Both the East Collingswood and the West Collingswood Fire Companies were designated Fire Company No. 1.

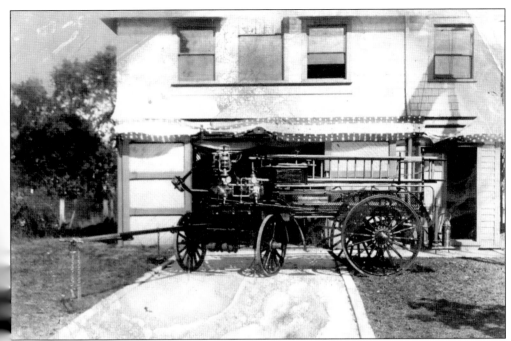

This early piece of fire equipment, which was drawn by horses, is shown in front of the West Collingswood Fire Company's firehouse. The firehouse was built in 1899 on Taylor Avenue.

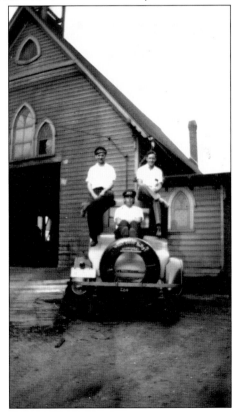

hree members of the East Collingswood
re Company, including Otto H. Bean Jr. on
e left, take a break in front of the old Holy
inity Episcopal Church building in 1928. The
riting on the front of the car tire whimsically
oclaims, "What Doin' Baby? Whoopee!"

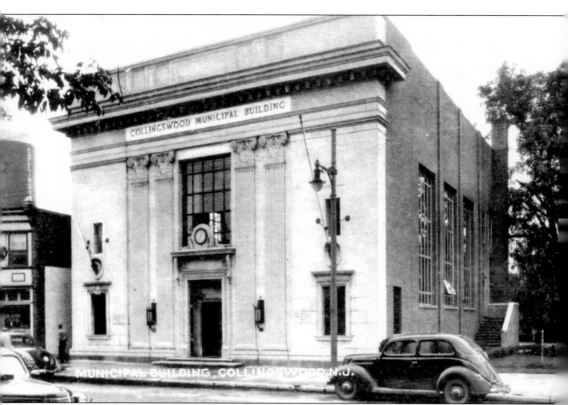

One of the earliest bank fatalities of the Great Depression was the Collingswood Trust Company on Haddon Avenue, near Collings Avenue, causing many residents to lose their life savings. Several years later, the Borough of Collingswood purchased the old bank building for use as its municipal building. Prior to that, the borough had offices in the East Collingswood Fire Company's firehouse.

Seven

DOING BUSINESS

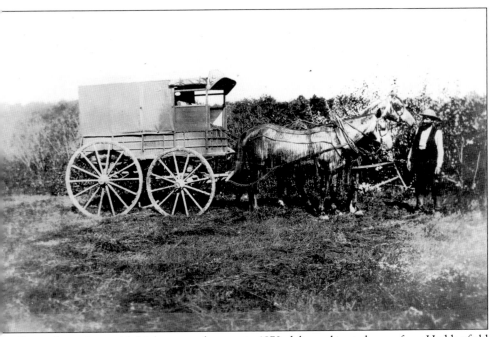

sac Prine, shown here with his horses and wagon in 1872, delivered ice to homes from Haddonfield Camden. Prine harvested ice from Cuthbert Lake, a millpond that once existed near Cuthbert oad, and stored it in an icehouse located at Browning Road and Cooper's Creek.

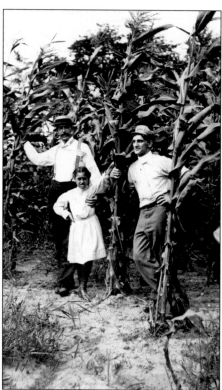

Collingswood farmers stand among their corn crop around 1880. Most of the farms in the area grew corn to use as feed for livestock.

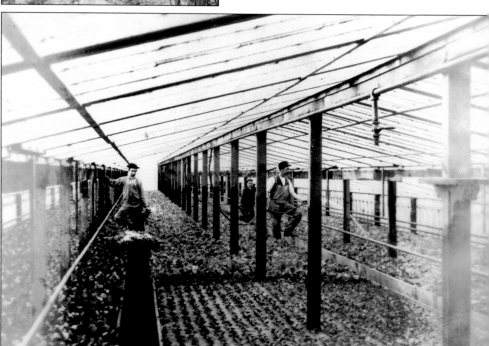

John C. Escher's greenhouse stood at 24 Lees Avenue. Great greenhouses such as this one were common in the late 1800s, when families with spare acreage grew large supplies of vegetables such as lettuce, cabbage, and tomatoes, and shipped them off to the local markets.

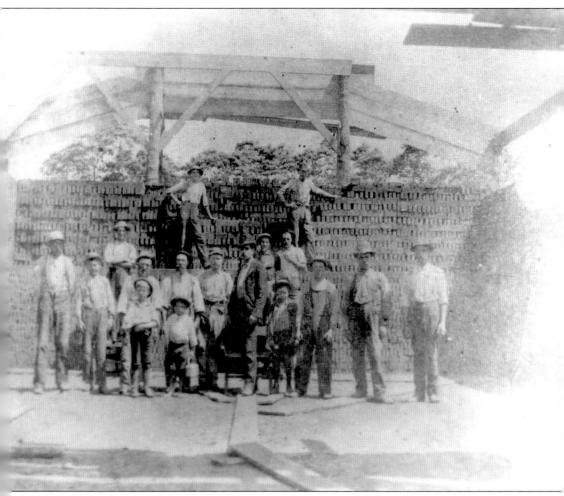

Pictured in 1889, Elmer C. Magill's brickyard, located where Center and King Avenues stand today, was one of the town's most prosperous businesses at the time. Magill, looking quite dapper in his derby, stands in the center surrounded by his workers.

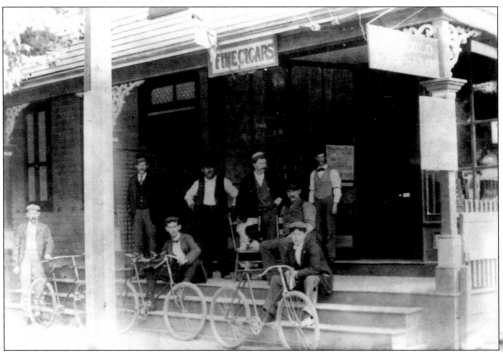

Harry Woods's poolroom, around 1897, was popular with Collingswood's liberal set. Seen here are, from left to right, J. States, Tinner Albertson, Bill Fish, Harry Woods, Gus Stutzer, barber Mart Fowler, Walt Dobbs, and Bert Rowes.

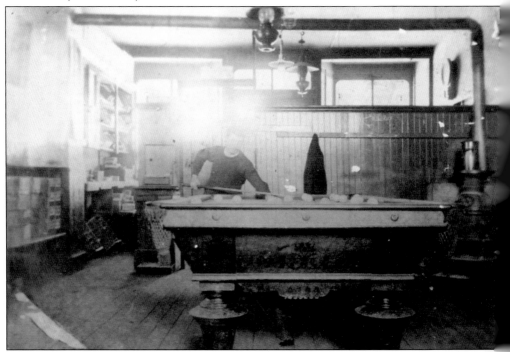

The inside of Harry Woods's poolroom, located in the 700 block of Haddon Avenue, was lit by hanging oil lamps and warmed by a potbelly stove.

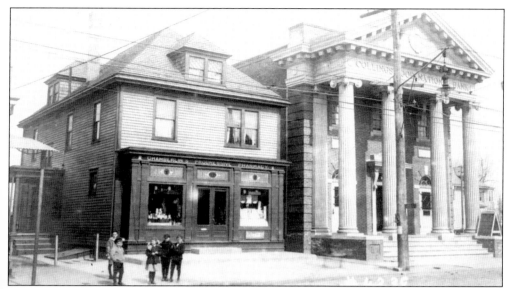

Around 1900, William A. Chamberlain opened a pharmacy at 24 West Collings Avenue near the East Collingswood Fire Company's firehouse. The pharmacy housed the first telephone switchboard in Collingswood, which was operated by Chamberlain and his clerk, William Major, when they were not waiting on customers. In 1902, Chamberlain moved his business to the location shown here at 815 Haddon Avenue, near Frazier Avenue. When the business relocated to this location, the switchboard was transferred to the second floor of Tatem Hall.

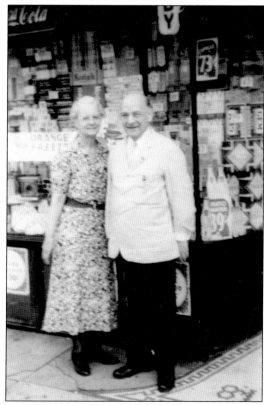

This photograph was taken of William . Chamberlain and his wife, prominent ollingswood citizens for several decades, tside of Chamberlain's Pharmacy on addon Avenue.

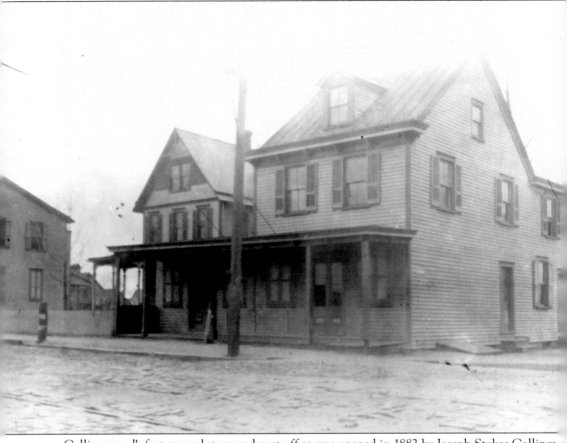

Collingswood's first general store and post office was opened in 1882 by Joseph Stokes Collings, who served as postmaster, at the corner of Haddon and Collings Avenues. Residents of small villages like Collingswood were dependent on general stores such as Stokes's for their groceries, dry goods, and hardware.

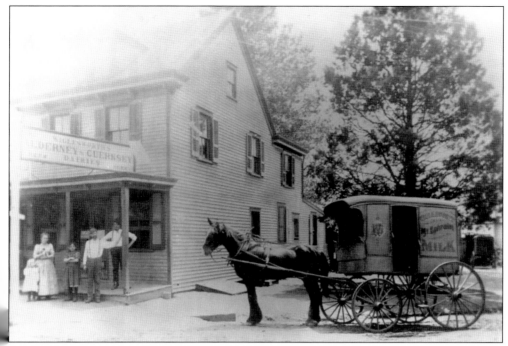

Stokes's general store at Haddon and Collings Avenues later was taken over by Edward Wrigglesworth. His dairy store and delivery wagon are shown here. Many store owners at that time delivered merchandise to customers via wagon.

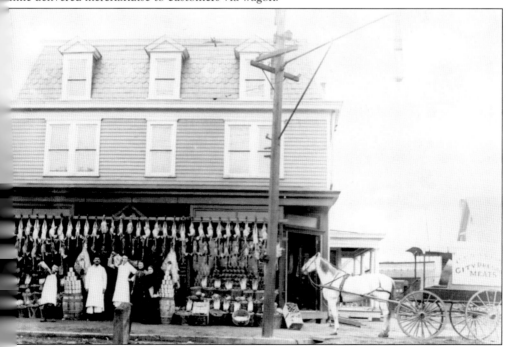

riginally Stokes's general store, the business again changed hands from Edward Wrigglesworth C. J. Taylor, who expanded the building and opened his "Meat and Provisions" ocery store.

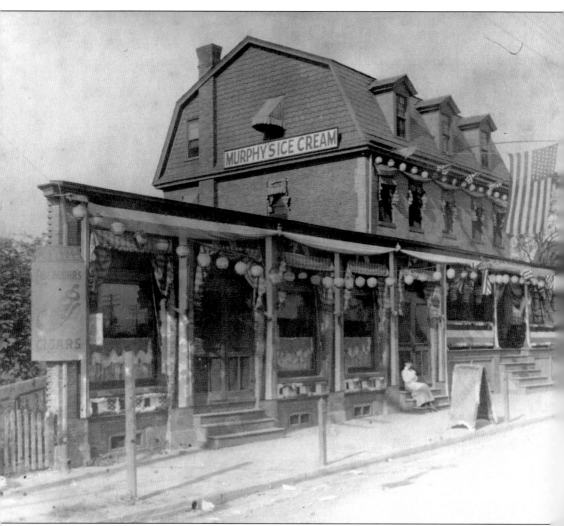

Maurice Murphy, said to be the town's first and only Democratic Party member, made his "Dew Drop" ice cream, a delicacy of the time period, at the rear of his home and store. Murphy's located on Collings Avenue near the railroad station at Atlantic Avenue, was a popular dating spot for young residents. In this photograph, the store is decorated patriotically in honor of Collingswood's 20th anniversary in 1908.

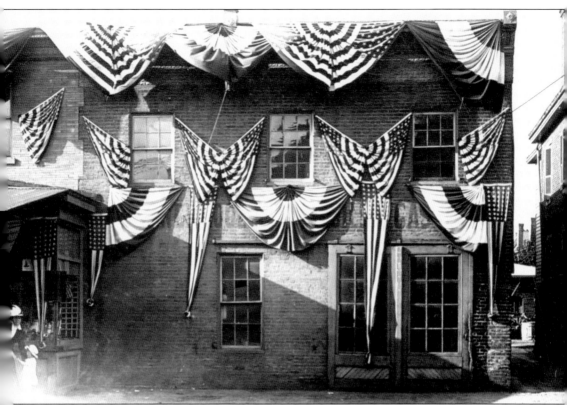

Henry Frech's Hardware Emporium and Blacksmith Shop was located at 709 Haddon Avenue between Collings and Washington Avenues. Pictured here in 1908, the shop was decorated for Collingswood's 20th anniversary celebration.

In 1904, Charley Wong moved into a store on Haddon Avenue and opened one of the town's first laundry services. Wong eventually relocated his business to Philadelphia, but the laundry in Collingswood continued to bear his name for many years.

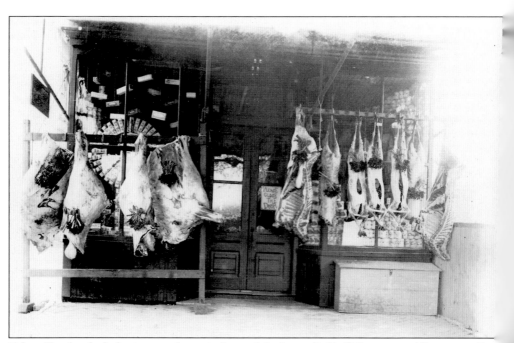

Sides of beef and whole pigs were hung in front of the James R. Duff Grocery and Provisions Store on Collings Avenue around 1905. At a time before refrigeration, fresh meat was quite popular.

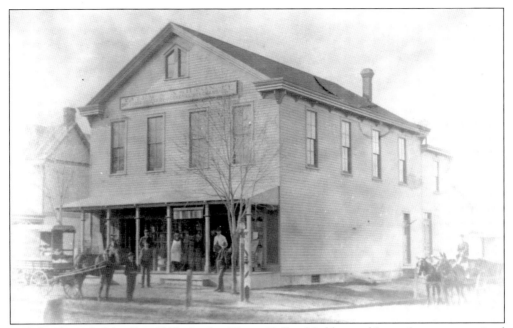

Built by Elmer C. Magill in 1885, the first Tatem Hall at Haddon and Irvin Avenues contained a grocery store, post office, and poolroom. On the second floor, town meetings were held, and secular groups who had no church of their own met here on Sundays for their individual services. The building was destroyed by the town's great fire of 1913.

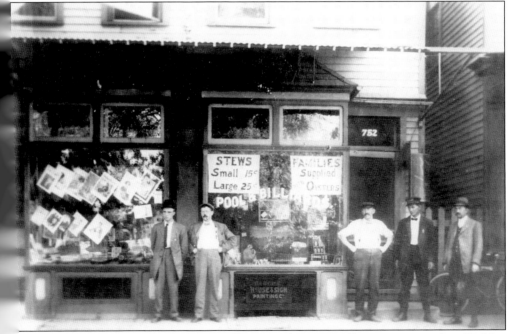

After fire destroyed the original Tatem Hall, a second Tatem Hall was constructed on Haddon Avenue facing Frazier Avenue. It was occupied by Charlie Sutton's store, which offered a poolroom and smoke shop. As evident in the photograph, men enjoyed loitering in the doorway of the shop, and a sign was posted to remind them to "spit in the gutter as you would at home."

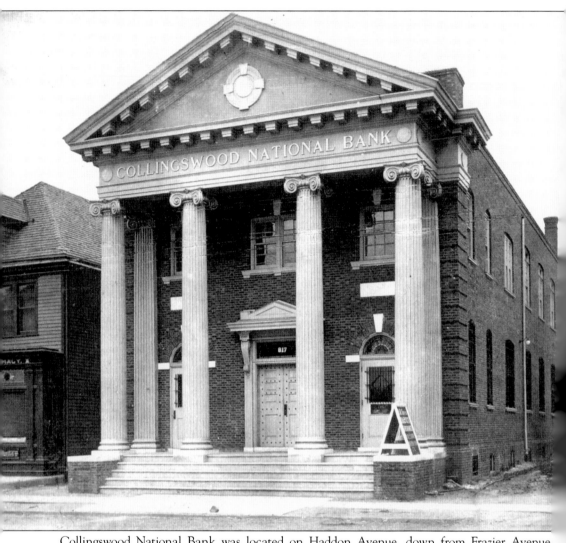

Collingswood National Bank was located on Haddon Avenue, down from Frazier Avenue between Chamberlain's Pharmacy and the Collingswood Public Library. Opened in 1905, the Classical Revival–style building, with its ornate columns, was a stark contrast to the other, more modest buildings surrounding it. In the midst of the Great Depression in 1934, the Collingswood National Bank was closed, but soon reopened as Citizens National Bank.

Collingswood National Bank

Capital - - - $40,000

Surplus - - - 4,000

HENRY R. TATEM, President HOWARD K. HERITAGE, Vice Pres. DAVID S. RASH, Cashier

DIRECTORS

WILLIAM A. CHAMBERLIN	EDWARD S. OLIVER	EDWARD S. SHELDON
HOWARD K. HERITAGE	WILLIAM D. SHERRERD	HENRY R. TATEM
WILLIAM C. LORE	WALTER L. PATTERSON	J. FITHIAN TATEM

We solicit business and personal accounts and offer every accommodation consistent with good business methods. Saving fund accounts, 3% interest, subject to 10 days notice of withdrawal. Safe deposit boxes to rent in burglar-proof vaults, three dollars per annum and upwards.

This 1908 advertisement touts the services of the Collingswood National Bank, under the direction of the bank's president, Henry R. Tatem. The bank proudly offered "every accommodation consistent with good business methods."

mployees of the Collingswood National Bank
ther on the steps of the building in 1920. The
ung boy sitting down on the steps was the son
the bank's cashier David S. Rash.

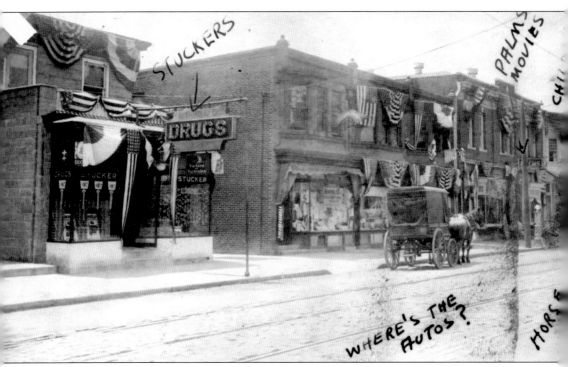

Considered the most important commercial block in Collingswood at the time, this section of Haddon Avenue, across from Frazier Avenue, was destroyed by one of the worst fires in the town's history in February 1913. It was started during the construction of Collingswood's first modern movie palace on Haddon Avenue, near Irvin Avenue, and not only destroyed this row of businesses, but also severely damaged homes on Irvin Avenue, the Zane School, and stores across the street. Modern two-story brick units were later constructed in place of the destroyed commercial buildings on Haddon Avenue.

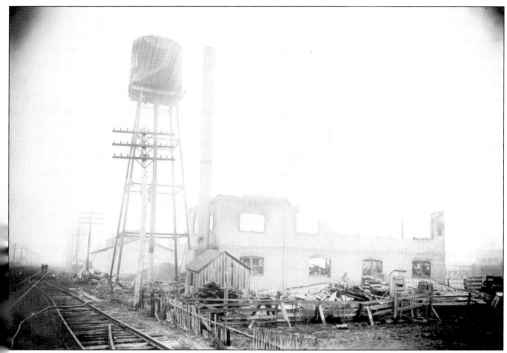

Located near the railroad tracks on Atlantic Avenue, the Enterprise Wall Paper Factory was destroyed by fire on February 2, 1915. The factory was gutted and never rebuilt.

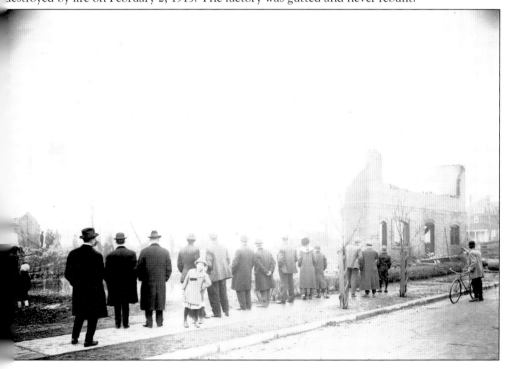

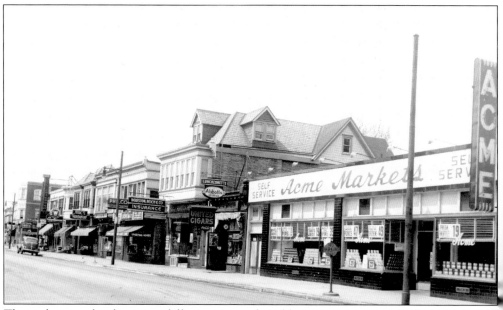

These photographs show two different views of Haddon Avenue around 1930. At the time, Collingswood, along with the rest of the country, was in the throes of the Great Depression. Businesses were suffering, and unemployment soared.

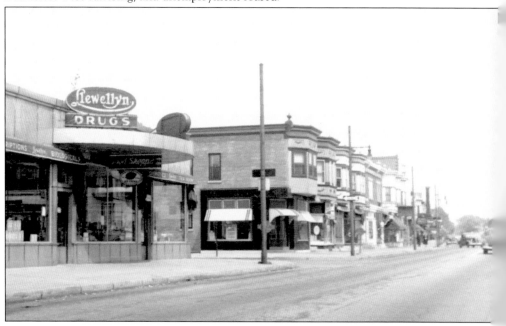

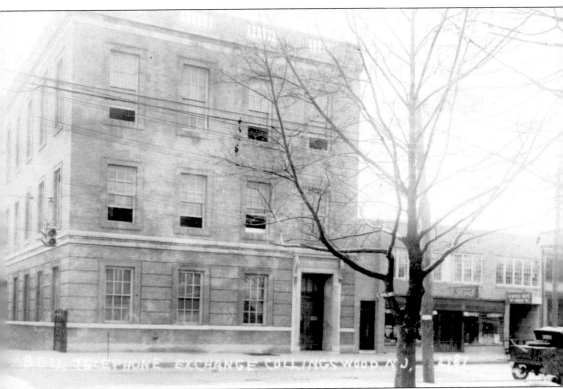

The Bell Telephone Collingswood Business Office was opened to serve Collingswood subscribers on January 23, 1932. Prior to that, residents conducted their business through the nearby Camden office. The history of the telephone in Collingswood began many years before that in 1896, when the first telephone in town was installed in the country store of L. Frank Hurff, who also served as postmaster at the time, in Tatem Hall. It was the only telephone in town for several years, and initially connected to a switchboard in Camden until Collingswood acquired its own switchboard in 1901.

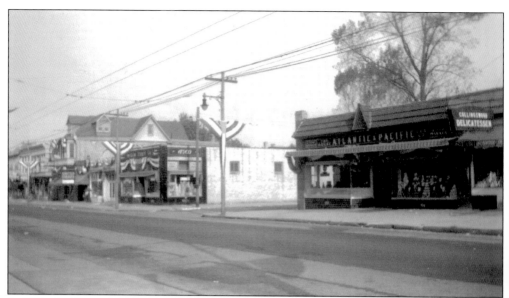

In 1938, the Great Atlantic and Pacific Tea Company, also known as A&P, stood on the corner of Haddon and Washington Avenues, where National Food Market resides today. At the time, A&P was the number one grocery store in the country with approximately 16,000 stores nationwide. Surely many Collingswood residents visited this A&P for its popular *Woman's Day* magazine, which sold at the time for 2¢ a copy, and Eight O' Clock coffee. (Courtesy of Sandra Powell.)

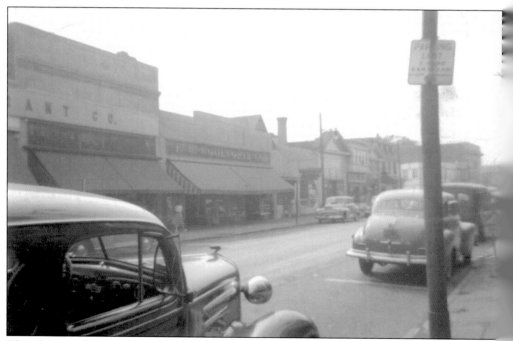

This photograph was taken of Haddon Avenue, east of Collings Avenue, in the late 1930s. The buildings shown were constructed around 1930 as department stores for F. W. Woolworth and W. T. Grant and Company. This building type was prevalent in commercial areas during the years between World Wars I and II. (Courtesy of Sandra Powell.)

Eight

MODES OF
TRANSPORTATION

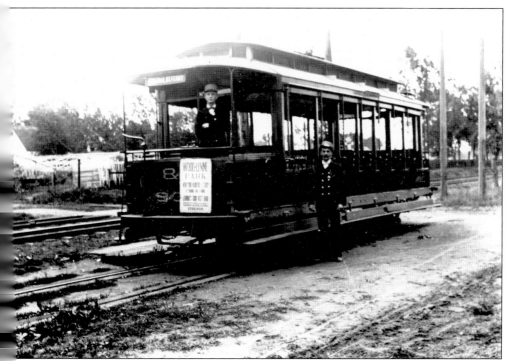

the 1890s, trolley service began on Haddon Avenue. By the early 1900s, a second trolley line
gan running on Atlantic Avenue. It was a popular mode of transportation among residents,
ho could easily catch a ride for 5¢. Open-air trolleys such as this one, shown at the corner of
tlantic and Lees Avenues, were used on hot days. In the event of rain, there were curtains that
lled down almost to the floor to protect passengers from the elements.

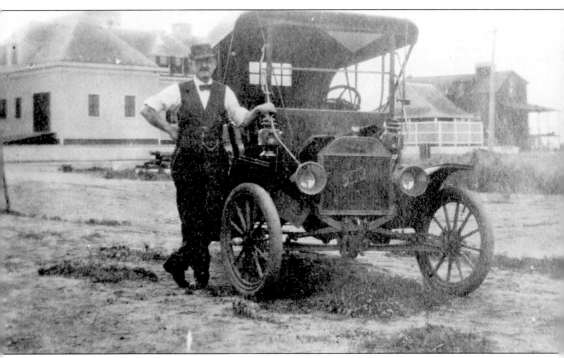

Collingswood resident Charles Quint owned the first Ford automobile in town. He proudly stands beside it in this photographed dated May 1901. At the time, the Borough of Collingswood requested that county detectives be placed along the White Horse Pike to strictly enforce the speed limit of 10 miles per hour.

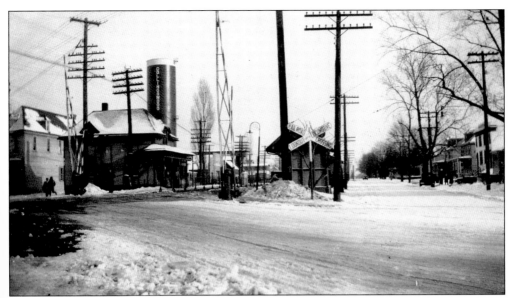

The Collingswood station of the Camden and Atlantic Railroad, which ran from Philadelphia to Atlantic City, was built at Collings and Atlantic Avenues in 1885. Collingswood's designation as a stop on the railroad helped to fuel its rapid population growth in the town's formative years.

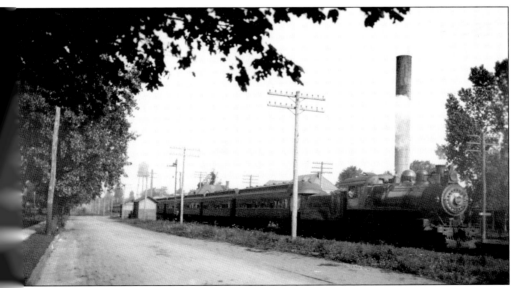

oal-burning trains such as this one ran through Collingswood, along Atlantic Avenue, from 77 to about 1967. Note the old water standpipe behind the train, which later collapsed.

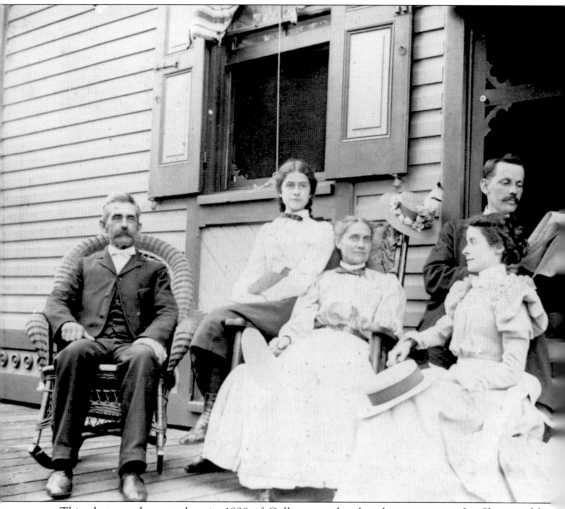

This photograph was taken in 1898 of Collingswood railroad station agent Ira Shaw and his family relaxing on the station platform facing Collings Avenue. At the time, Shaw and his family lived in an apartment above the station. In this photograph, he reads the newspaper surrounded by his wife, parents, and sister.

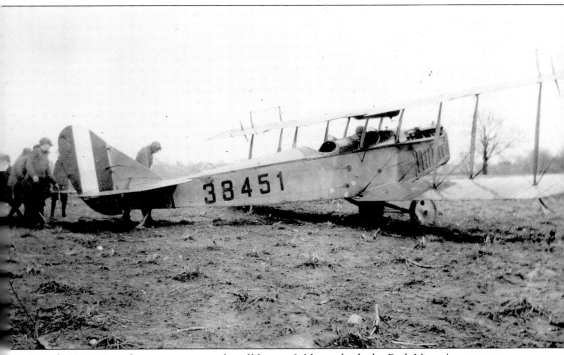

On March 22, 1919, a plane prepares to take off from a field on which the Park View Apartments later would be erected.

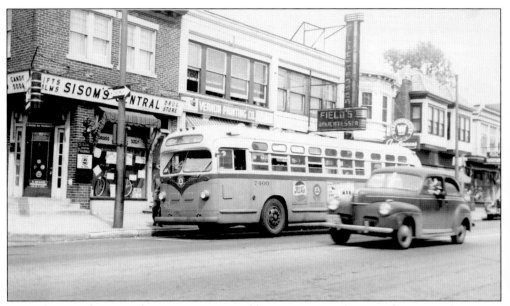

Around 1930, a bus stops for passengers on Haddon Avenue. At this time, buses were becoming a popular means of transportation. Also at this time, more and more residents were buying new cars.

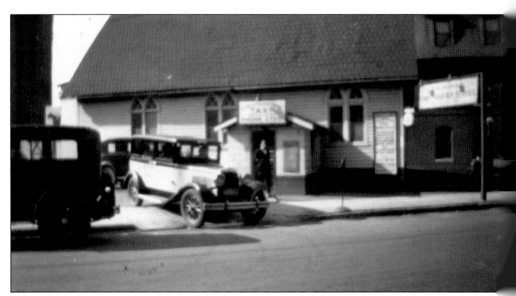

This 1928 photograph was taken of a cab station operated by the Collingswood Taxi Service. The station was located at Collings and Haddon Avenues, in the structure that originally housed the Holy Trinity Episcopal Church.

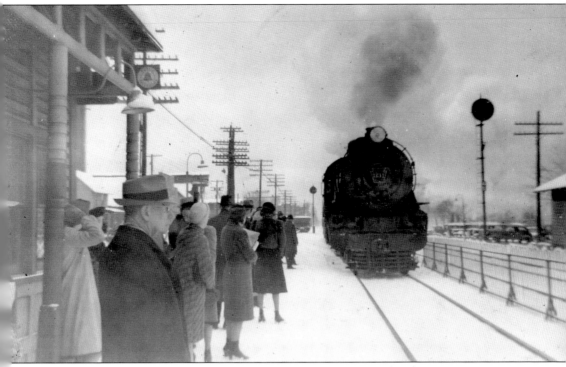

The 8:03 a.m. train arrives at the Collingswood station at Collings and Atlantic Avenues on January 27, 1941. Around this time, about 28 trains passed through the station, with 7 stopping for commuters.

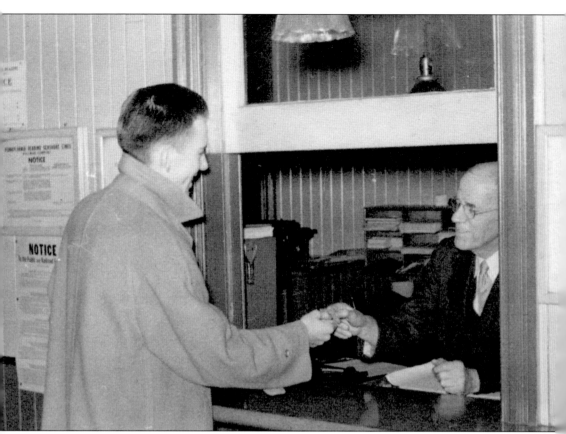

George Diffenderfer buys the last train ticket sold by Collingswood railroad station agent Ira Shaw, who then retired after 58 years of service on December 31, 1942.

BIBLIOGRAPHY

Collingswood Centennial 1888-1988: The First One Hundred Years. Collingswood: self-published, 1988.

Bancroft, Raymond Mitchell. *Collingswood Story*. Collingswood: self-published, 1965.

D'Alessandro, John T. *The Collingswood Bicentennial Book*. Collingswood: self-published, 1976.

Dorwart, Jeffery M. *Camden County, New Jersey: The Making of a Metropolitan Community, 1626-2000*. New Brunswick: Rutgers University Press, 2001.

Dorwart, Jeffery M., and Philip English Mackey. *Camden County, New Jersey 1616-1976: A Narrative History*. Camden County: Camden County Cultural and Heritage Commission, 1976.

Frambes, Douglas. *Hail Panthers—Here They Come: A History of Collingswood Football, 1909-1983*. Haddonfield: Sinnickson Chew and Sons, Inc., 1983.

McMahon, William. *South Jersey Towns: History and Legend*. New Brunswick: Rutgers University Press, 1973.

Newberry, Lida. *New Jersey: A Guide to Its Present and Past*. New York: Hastings House, 1977.

Raible, Dennis G. *Down a Country Lane*. Camden: Camden County Historical Society, 1998.

DISCOVER THOUSANDS OF LOCAL HISTORY BOOKS FEATURING MILLIONS OF VINTAGE IMAGES

Arcadia Publishing, the leading local history publisher in the United States, is committed to making history accessible and meaningful through publishing books that celebrate and preserve the heritage of America's people and places.

Find more books like this at
www.arcadiapublishing.com

Search for your hometown history, your old stomping grounds, and even your favorite sports team.

Consistent with our mission to preserve history on a local level, this book was printed in South Carolina on American-made paper and manufactured entirely in the United States. Products carrying the accredited Forest Stewardship Council (FSC) label are printed on 100 percent FSC-certified paper.

MADE IN THE USA